IMAGES of America
SOUTHFIELD

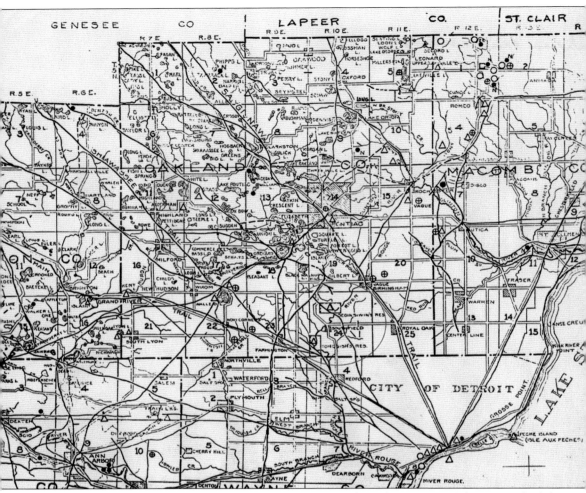

Southeast Michigan is the ancestral home of three Anishinaabe nations of the Council of the Three Fires: Potawatomi, Ojibwe, and Ottawa. The land that later became Southfield was located along several well-known footpaths that Native Americans used to travel from the southeast to areas in the north and west of modern-day Southfield. This photograph shows Southfield, portions of the Shiawassee Trail and the Grand River Trail, and two Native American reservations (Tonquish and Seginsiwin). (Courtesy of the Southfield Historical Society.)

ON THE COVER: Lawrence Technological University (LTU) first acquired property in Southfield in 1955. Pictured here, members of Southfield's City Council and administrators from LTU participate in a groundbreaking for the new science building on LTU's Southfield campus. (Courtesy of the Southfield Historical Society.)

IMAGES
of America

SOUTHFIELD

Cassandra M. Talley

ARCADIA
PUBLISHING

Copyright © 2025 by Cassandra M. Talley
ISBN 978-1-4671-6199-2

Published by Arcadia Publishing
Charleston, South Carolina

Printed in the United States of America

Library of Congress Control Number: 202494159

For all general information, please contact Arcadia Publishing:
Telephone 843-853-2070
Fax 843-853-0044
E-mail sales@arcadiapublishing.com

Visit us on the Internet at www.arcadiapublishing.com

To the passionate historians at the Southfield Historical Society (especially Darla Van Hoey) who made it plausible and to my family who made it possible.

Contents

Acknowledgments		6
Introduction		7
1.	Early History	9
2.	Pioneering Families	17
3.	From Agriculture to Subdivisions	29
4.	Industry and Commerce	37
5.	Education	53
6.	Religion	67
7.	Civic Development	79
8.	Life in Southfield	95
9.	Architectural Gems	117

Acknowledgments

I can pinpoint the exact time and place when I became a preservationist. I was sitting at home in my family's living room with my Dad, watching the nightly news broadcast, when a story came on about the demolition of the Clinton Valley Center (also known as the Pontiac State Hospital and the Eastern Michigan Asylum for the Insane before that). I was incensed that such a beautiful building was being demolished. Even at 15, I knew a building like that could never be reproduced. At the time, I didn't understand the complex issues inherent in preserving a building that had such terrible associations for so many, but nevertheless, the seeds were planted for a career I didn't yet know existed. Fast forward 19 years, I began my career as an architectural historian, researching and writing about Michigan's historic places. Four years after that, I moved to Southfield and began to familiarize myself with my new hometown.

I had no idea what I was getting into when I began this book, and I'd like to give a heartfelt thanks to Arcadia Publishing editor Amy Jarvis for remaining patient with me as I navigated my way (slowly) through this process. Thank you, Amy, for answering all of my questions and gently telling me how to properly scan a historic photograph. Darla Van Hoey was an invaluable resource and spent countless weekends sitting patiently with me at the Southfield Public Library—thank you, Darla!

The information contained in this book is partially the product of the excellent historical research conducted by many historians who came before me. If there are any errors here, they are mine alone. I referenced a variety of sources including books, maps, and the treasure trove of archives held within the Southfield Historical Society's collections. Southfield has had many newspapers over the years but because none have been digitized, I relied heavily on the indexed articles that the Southfield Historical Society has collected and cataloged in their archive. All the photographs featured in this book are drawn from the archives of the Southfield Historical Society unless noted otherwise.

Introduction

Native Americans of the Potawatomi, Ojibwe, and Odawa peoples occupied Southfield Township long before White settlers arrived. Early White Southfield residents spoke of finding arrowheads in their fields during plowing and cultivation, and other historical accounts indicate that small patches of maize and apple trees were found in Sections 9 and 30—these sections contained two Native American reservations in the 1810s and 1820s. First surveyed in 1817, Southfield Township was called Township 1 North Range 10 East, and the earliest White settlers began buying large tracts of land shortly thereafter. By the mid-1820s, the first settlers were beginning to build houses in the area. In 1830, the nascent township was officially named Ossewa; however, this was changed just a few days later to Southfield.

One of the earliest "town centers" in Southfield was called Crawford Corners (or Four Corners) and it was located at Ten Mile and Lahser. Early settler John Trowbridge had a farm at the southwest corner of this intersection, and, around 1832, he established a store on his property. Near Trowbridge's farm and general store, John Thomas and Abraham Crawford established a tavern and post office at the northeast corner of Ten Mile and Lahser Roads—this intersection became known as Crawford's Corners and a few additional enterprises coalesced in this location. However, in 1837, about a mile northwest of Crawford's Corners, Ezekiel Sabin built a mill where the Rouge River met Ten and a Half Mile Road (now called Civic Center Drive). With farmers waiting around Sabin's mill as their grain was processed, a new community sprang up to serve the incoming men. The area around Sabin's Mill later became known as Southfield Centre, Southfieldbergh, and later, just "the Burgh."

Southfield remained a rural farming community through the rest of the 1800s, and Southfield Centre continued to be the retail heart of the community. This began to change in the 1940s and 1950s. As Detroit grew to bursting, reaching a peak population of 1,849,568 in 1950, Detroit residents seeking more space and larger lots began looking to first-ring suburbs like Southfield as vacant lots in Detroit were increasingly scarce in the city. Southfield Township grew from 8,486 residents in 1940 to 18,499 residents in 1950. By 1960, the population swelled again to 42,820 (11,319 in Southfield Township and 31,501 in the City of Southfield). In 1960, Southfield Township consisted of Franklin, Bingham Farms, Beverly Hills, and a small section called Southfield Township.

The 1950s brought a flurry of development, and civic activity was initiated to keep pace with the development. In the mid-1950s, a water main was extended from Eight Mile Road up Greenfield Road to Fourteen Mile, and Oakland County officials were weighing whether to extend sewers throughout the township. Schools in particular became a priority because the existing district schools in Southfield were increasingly crowded. Leaders in Southfield were also alarmed at continued attempts by neighboring municipalities to annex parts of the township. In 1953, it was rumored that Berkley was considering an annex of the northeast portion of Southfield that adjoined Berkley. Oak Park, too, attempted to annex the portion of Southfield where Northland Center was being built.

These tensions resulted in a push for school consolidation in the late 1940s. There was great strife in the small community over whether the disparate schools, none large enough to support a high school, should consolidate. Students from Southfield Township's lower schools ended up traveling to Birmingham, Royal Oak, Detroit, or other locations in order to complete their education. A concerted effort by Charles Kelley (husband of the late Louise Lathrup) and Bert Gale fought against consolidation as men like school board president Fred Leonhard tried to rally the community for consolidation. Eventually, Southfield's schools were consolidated in 1947.

The effort to incorporate Southfield Township into a city was similarly fraught. The first attempt in 1956 was thwarted. A second attempt fell short by 44 votes, but finally, in 1958, Southfield became a city. With this newfound status came a push by city leaders to develop services and a municipal building that would suit the needs of this growing community. The Southfield Civic Center, opened in 1964, provided a new library, parks and recreation building, and a combined city hall–police building. In the 1960s, new water mains were installed via municipal bonds and Northwestern Highway opened as an extension of the Lodge Freeway. Southfield was suddenly highly accessible to anyone with a car and the population skyrocketed accordingly in the 1960s. Southfield's population grew to 69,285 in 1970, and some projections anticipate growth into the six digits in the ensuing decades. It never grew to that size, and today, Southfield has just over 75,000 residents.

In the 1970s, Southfield began welcoming some of the first Black families who joined a community that was already highly diverse. In the late 1970s or early 1980s, the City of Southfield's Planning Department calculated that Southfield was approximately 40 percent Jewish, 10 percent Chaldean, and 9 percent Black, presumably meaning the remaining population was predominately White. Smith Carson and his family were reportedly the first Black family to build a house in Southfield—they moved into their new home on Woodhaven Street in 1964. A Chaldean Church, Our Lady of Chaldean Cathedral, located on Berg Road near Ten Mile attracted Chaldean families to Southfield in the 1970s. Southfield also has religious organizations catering to Lithuanian, Armenian, Korean, Ukrainian, Albanian, Romanian, and Syriac Orthodox populations as well as several African Methodist Episcopal, Baptist, Catholic, Presbyterian, Buddhist, and Muslim congregations. Today, Southfield is vibrantly multicultural and multiethnic, and this diversity is one of the characteristics most cherished by many Southfield residents. Many civic leaders and neighborhood associations banded together to embrace integration and Southfield has long been associated with inclusivity and multi-ethnic, multi-religious, and multi-racial neighborhoods.

Southfield is also a destination for architectural enthusiasts due to its concentration of mid-20th-century buildings designed by some of America's most prominent architects. World-famous architects like Minoru Yamasaki, Earl Pellerin, and Gunnar Birkerts all designed buildings in Southfield. These high-caliber architects were retained in part because Southfield has a large concentration of successful corporations that sought to build headquarters that embraced modernist design principles and advanced building materials as an expression of their companies' innovative and forward-thinking mentality. Southfield also has a wealth of single-family homes designed in the mid-century modern style, which boomed in popularity amongst homebuyers after modern furniture company Design Within Reach was launched in 1999, IKEA's sleek Scandinavian designs spread across the country in the 1990s and 2000s, and Mad Men went on the air in 2007. Driving through neighborhoods like Washington Heights, Cranbrook Village, Plumbrooke Estates, Northland Gardens, and the Ravines is to see an architectural tour de force on display with many custom, architect-designed homes set amongst mature trees and established landscaping.

One

EARLY HISTORY

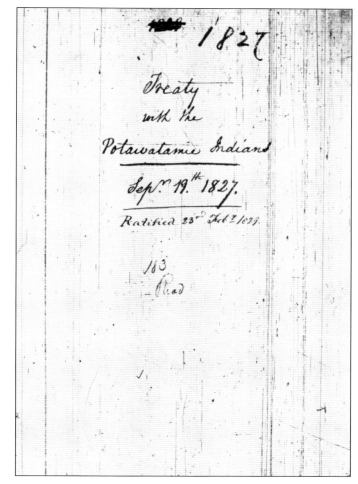

Southfield was long home to the Potawatomi, Ojibwe, and Odawa peoples. Most land in southeast Michigan was ceded from Native Americans to the Governor of the Michigan Territory in 1807 via the Treaty of Detroit. However, several reservations, including two in Southfield, were the exception: the Tonquish and Seginsiwin reservations located along the banks of the Rouge River. In 1827, the Potawatomi peoples signed a treaty giving up their ownership of the Tonquish and Seginsiwin reservations in exchange for a large reservation on the border of Kalamazoo and St. Joseph counties in West Michigan. The title page of the treaty is shown here.

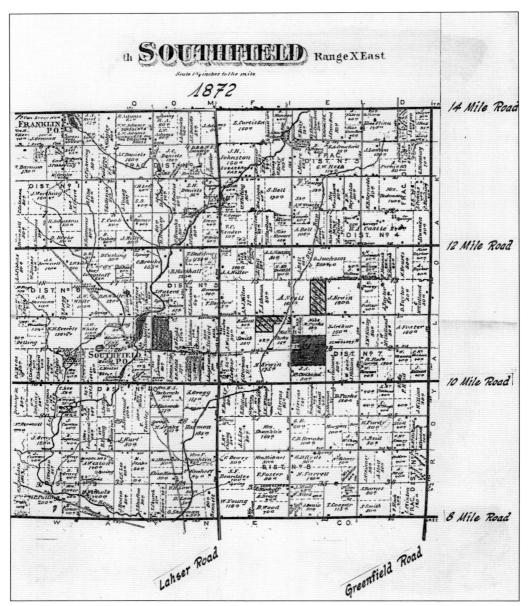

An 1872 map of Southfield shows the various landowners in the township including the size of their land holdings, in acres. The map also marks the section numbers (found in the center of each section), schoolhouses, and the Rouge River with its various branches and tributaries. In section 32, the notation "School No. 9" on A. Weston's property was later known as the Klett school for the family that later lived on this land. The black dots and large pond located just above the "Southfield PO" notation is the location of the historic town center of Southfield. The pond is the result of a dam made on the Rouge River to power the local mill owned by the Sabin family.

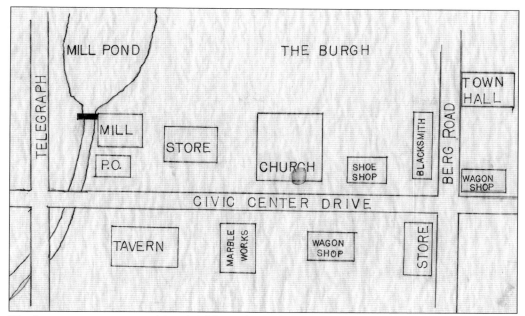

The historic town center of Southfield was located at the corner of Berg Road and Ten and a Half Mile Road. Above, a hand-drawn map shows the businesses in operation in the early days of Southfield's history. A post office, several stores, a shoe store, and a mill are all shown here. On the next page is an undated photograph of the mill, historically called Sabin's Mill, which was located along the Rouge River in the old town center.

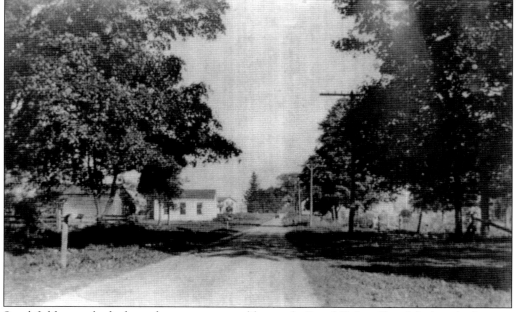

Southfield never had a large downtown center like nearby Royal Oak or Ferndale, but the historic town center did provide basic necessities to the local farming families. This undated photograph shows Ten and a Half Mile Road (Civic Center Drive) looking east from Telegraph. The Methodist church is visible on the left while a farmhouse is shown in the background.

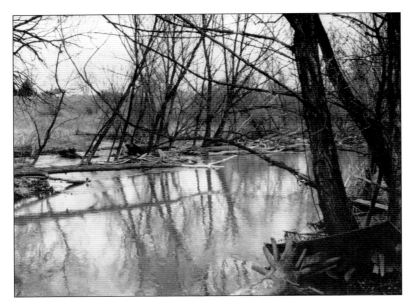

Several branches of the Rouge River (and several major tributaries to it) flows through Southfield. The presence of rivers, creeks, and streams are prevalent all over the city contributing to the rolling topography seen around Southfield. This undated photograph of the Rouge River depicts a typical scene along its banks.

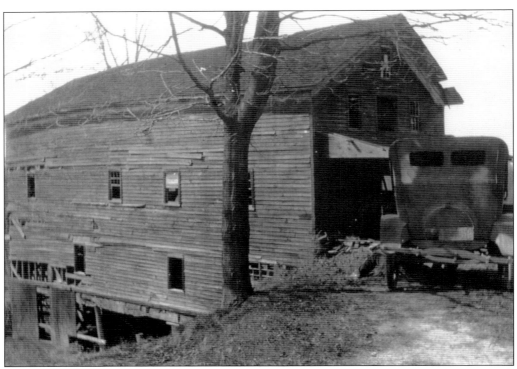

Built by the Sabin family and located in the old historic town center on Ten and a Half Mile Road, the Sabin Mill utilized a dam on the Rouge River to power the mill. Water-powered mills were common in Michigan as the flow of the river provided enough power to run saw and grain mills like this one.

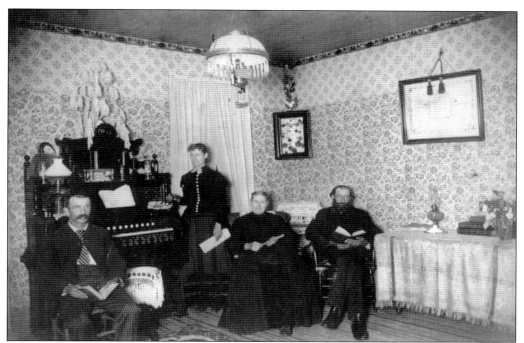

The Sabin family are pictured here in the parlor of their home around 1890–1900. Ezekiel H. Sabin was the patriarch of the family, having built the grist mill on the Rouge River in 1837. Sabin served as the Southfield township clerk and justice of the peace from 1839 to 1840.

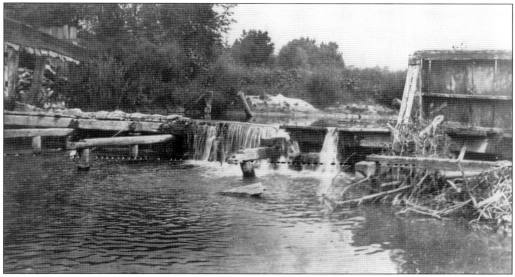

The remnants of the dam and pond that helped power the Sabin mill are shown here in this undated photograph. Longtime residents of Southfield remember harvesting ice on the "mill pond." The 1850 census recorded several millers in Southfield including John German and John Trowbridge (Sabin had left Southfield for Livingston County in 1841–1842). With 149 farms recorded in the census that same year there was enough grain to support millers like German and Trowbridge.

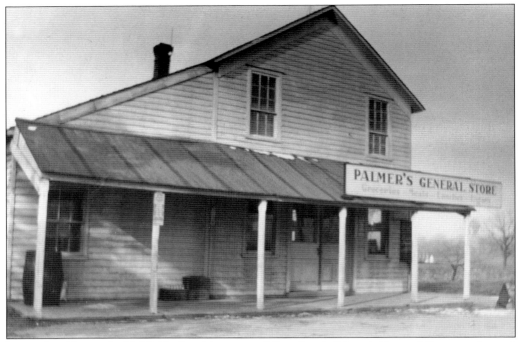

Located on Ten and a Half Mile Road just west of Berg Road, Palmer's General Store was located in the historic town center of Southfield known alternately as Southfield Center and The Burgh. The store was originally known as the Dunbar Store after its owner, Lysander M. Dunar. Lysander was elected Township Clerk in 1873. The second owner of the store was J.H. Palmer, who also owned 67 acres near the northeast corner of Beech and Nine Mile Roads. According to the sign, it sold groceries, meat, lunches, cigars, and other items.

The Southfield Township Hall was built sometime around 1872 and was a multipurpose building in its early days serving as the home for all township-related activities as well as social meetings and other civic events. The township hall is the only 19th-century historic building in Southfield's historic district, the Burgh, that has not been moved. The woman pictured here is Fannie Adams, longtime township clerk in Southfield. (Courtesy of Walter P. Reuther Library, Archives of Labor and Urban Affairs, Wayne State University.)

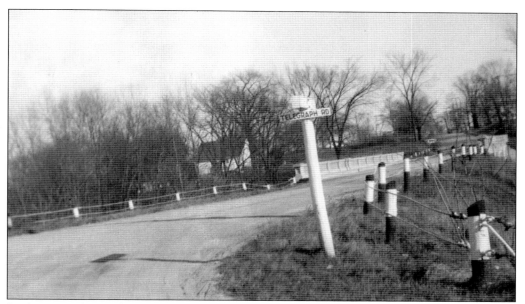

Looking east from Telegraph Road, Civic Center Drive and the bridge over the Rouge River are shown here in this undated photograph. By the time this photograph was taken, the old town center of Southfield was no longer a hub for commerce or services—the remaining buildings in the background of this photograph are likely all residential houses.

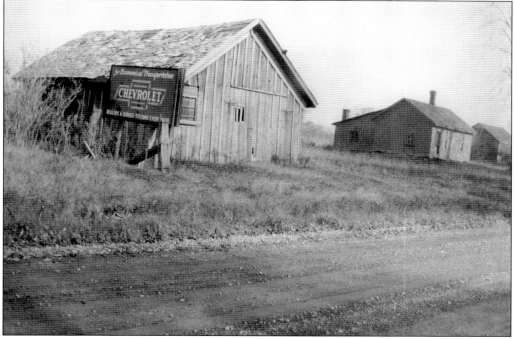

This photograph shows three early Southfield buildings, a barn in the foreground, a small farmhouse in the midground, and another small barn in the background. This photograph was likely taken on Ten and a Half Mile Road and poetically juxtaposes the infiltration of the new (a Chevrolet dealership) with the fading agricultural heritage of Southfield's past (the barns and farmhouse).

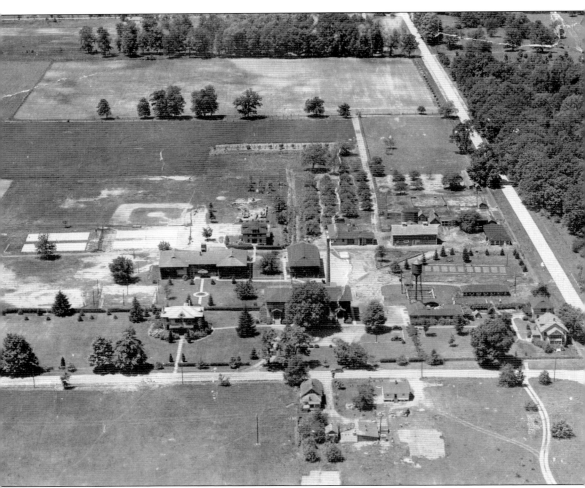

Located at the western edge of Southfield, just across Inkster Road in Farmington, Michigan, the Boys Home and d'Arcambal Association was a home for orphaned and neglected boys. Incorporated in 1890 as the Home of Industry, the organization changed its focus from aiding released prisoners to assisting neglected children in 1906. At that time, it was renamed the Boys Home d'Arcambal Association in honor of its founder, Agnes d'Arcambal. Originally located in Detroit, the organization moved to its location on Inkster Road in 1907. The boys took part in educational classes, manual training, and farmwork. The school went through several names including the Ford Republic (due to major funding by the Ford family) and the Boys Republic. The school was unique for its style of self-government where the boys elected their own officers and ran their own bank, store, and court.

Two
PIONEERING FAMILIES

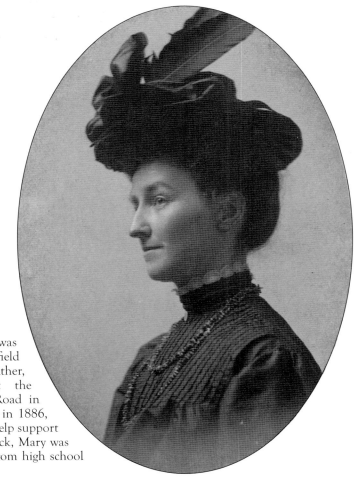

Mary Elizabeth Thompson was born into an early Southfield pioneering family. Her father, James Thompson, bought the family farm on Evergreen Road in 1870. When her father died in 1886, Mary had to leave school to help support the family. Despite this setback, Mary was eventually able to graduate from high school in Birmingham, Michigan.

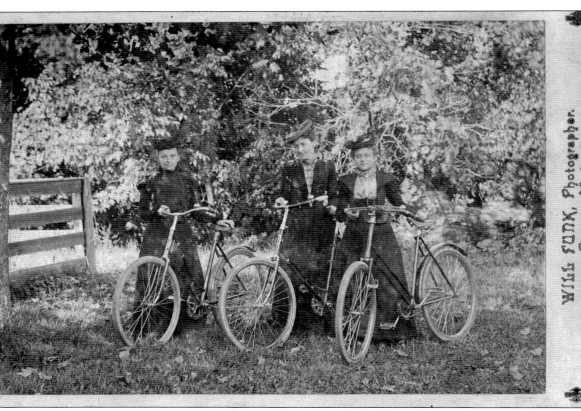

In 1898, Mary Thompson completed her teaching degree from Michigan State Normal College (now Eastern Michigan University) and went on to earn a master's degree from Columbia University in 1905, a master of pedagogy degree from State Normal College at Mt. Pleasant (now Central Michigan University) in 1907, and a doctorate in education from New York University in 1909. After graduating from the Michigan State Normal College in Ypsilanti, Mary Thompson spent several years teaching school in Michigan. Highly educated and very well-traveled for a woman of this era, Mary Thompson is pictured in the center of this photograph in 1899 along with fellow teachers Eva Ditzel at left and Eva Wistervelt at right.

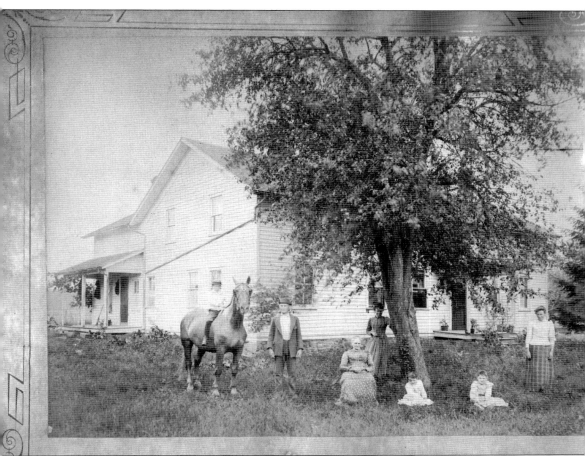

Mary Thompson returned to Southfield in 1912 to help care for her elderly mother. Mary taught at several area schools including the Beddows School (the Brooks School), the McKinley School, and the Brace School. Mary and her brother James were highly philanthropic and generous with their resources. The pair sold 166 acres to the City of Southfield at half its market value in 1959, which enabled the city to build the Southfield Civic Center on Evergreen Drive. Upon her death in 1967, Mary left her farmhouse and surrounding land to the City of Southfield with the intention that it be used by the citizens of Southfield. The Thompson family is pictured here sometime before 1914; James Thompson stands at left, Mary stands under the tree, Mary's sister Rachel is at the far right, and Mary's mother Margaret is seated at center.

The Beddow farmhouse is shown here in 1966. Southfield was a rural farming community for much of its history and farmhouses like this would have been a regular feature in the area. The Beddow family were early pioneers in Southfield, and they operated a cheese factory located just east of the Lahser and Eleven Mile intersection.

In 1966, the Beddow farmhouse was moved from its original location on Eleven Mile Road to Melrose Avenue. This photograph shows the house in its new location—the concrete masonry unit (CMU) blocks are piled next to the newly built foundation. The Beddows also donated land for one of Southfield's earliest schools, known initially as the Beddow School, and later renamed the Brooks School.

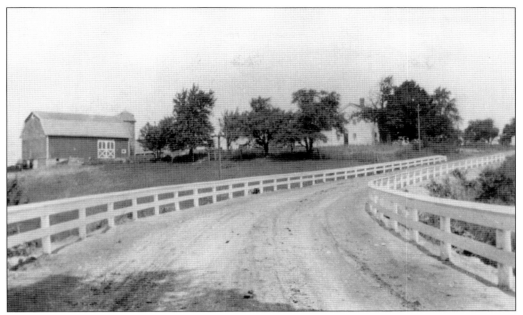

The Hooper farm is shown here in an undated photograph. The Hooper family lived on Franklin Road just west of Telegraph. For much of its history Southfield was exceedingly rural, and most families farmed crops and raised livestock to support themselves as evidenced by the large barn, silo, and fruit trees in this picture.

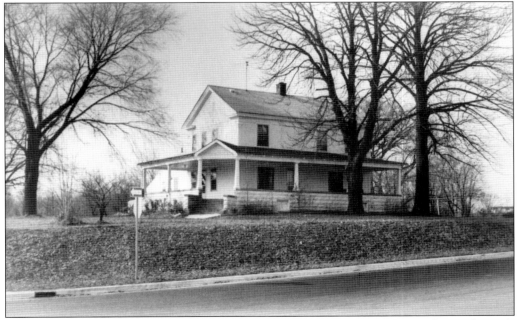

Another view of the Hooper farmhouse taken much later, is shown here. The porch was obviously a later addition to the original farmhouse. Family patriarch Charles Barnabas Hooper was a farmer and worked as a blacksmith for this small farming community.

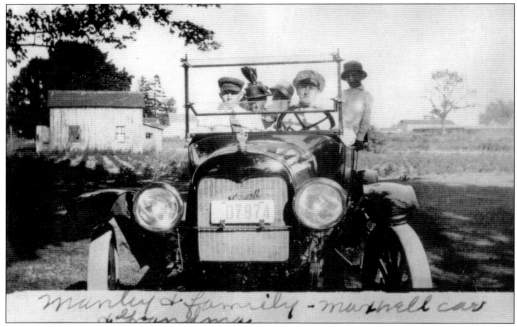

Members of the Hooper family gaze out the windshield of a Maxwell automobile. This appears to be a 1916–1917 Maxwell Touring car dating this photograph to sometime after 1916.

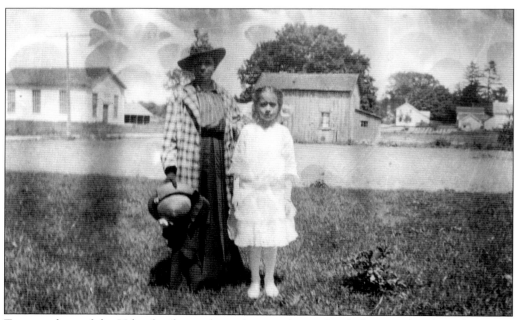

Two members of the Utley family are shown here in this undated photograph. The Utley family lived on the south side of Ten and a Half Mile Road just east of the Rouge River. This photograph and the one above it (of the Hooper family) were both taken from a similar vantage point with the same shed and house in the background.

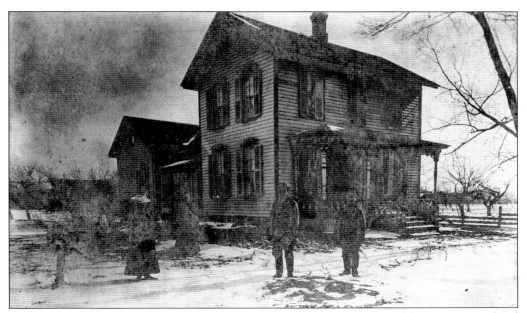

The Klett family and their Folk Victorian–style farmhouse are pictured here in an undated photograph. Family members pose outside the Victorian-style farmhouse. The Klett family were early settlers in Southfield and owned a 140-acre farm at the corner of Nine Mile and Beech Roads. (Author's collection.)

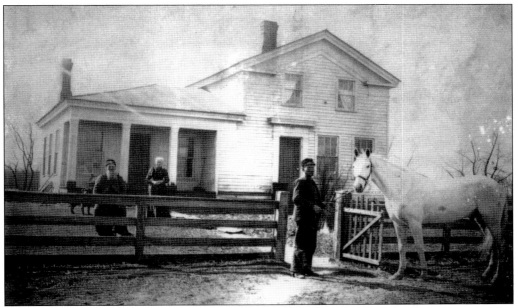

The Jenks/Lee family farm located on Berg Road is shown here in an undated photograph. This house was built by Morris Jenks, another Southfield pioneer, and was later occupied by the Lee family when Morris Jenks's daughter Esther married Charles Norton Lee. Also known as Deer Lick Farm, the house is a fine example of the Greek Revival style, which was enormously popular in rural Michigan in the middle decades of the 1800s. The home still stands. From left to right are Charles Lees, Esther Jenks Lee, their son Llewellyn, and Prince, the horse.

Likely built in stages as the family needed additional space, the Thomas Larkins house was built around 1905. The central portion of the house has a full fieldstone basement while the front and back wings do not. The Larkins family had a stock and dairy farm on the property while later owners, the Saxons, ran a feed store in downtown Plymouth. The Larkins House is a fine local example of a Victorian-style home as the spindle work porch and the scalloped shingles in the gables are common features of this architectural style. This photograph was taken around 1928. (Courtesy of Darla Van Hoey.)

The Simmons house was constructed around 1870 and is now a part of the Burgh, which is a historical park comprised of some of Southfield's historic buildings. The Simmons house was originally located just east of the Rouge River on the north side of Ten and a Half Mile Road. Laura and Charles Simmons are pictured on the porch of their home in this undated photograph. The Simmons house was moved to the Burgh in 1974.

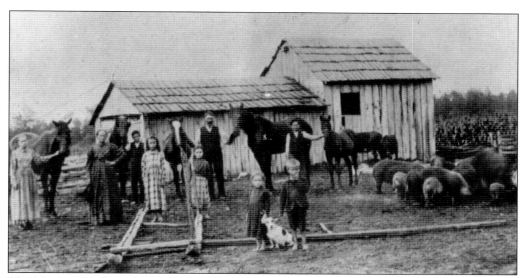

The Monroe family is shown in this photograph taken sometime around 1895. Little is known about this family; however, a Soloman and Mary Monroe are recorded in the 1900 census—Soloman is noted in the census as being a farmer. An 1896 plat map shows an S. Munroe-owned 40 acres along modern-day Evergreen Road north of 12 Mile.

The Churches family farmhouse was located at 24220 Nine Mile Road. Robert and Almira Churches were both born in Southfield. Mrs. Churches was born Almira Lee, and her grandfather was Morris Jenks. Robert and Almira celebrated their 60th wedding anniversary in March 1951. Churches Street and Almira Street are located where their farm used to be.

The Sturman House was located at 24625 West Ten Mile Road but is no longer extant. Called the Trowbridge Nursery, the farm was acquired by Samuel Sturman around 1856. The Sturman family raised 10 children on this farm, and their children, along with the children from the Jenks family, attended school just across Telegraph at the Old Stone School No. 10.

The Miller family lived on Twelve Mile Road on a farm known as Engle Knock Farm. In 1974, Leon Miller, pictured here, and his wife Lillie Miller sold about 10 acres of land to the City which eventually became Inglenook Park. The Miller's barn still stands in Inglenook Park. Miller also donated money to the City which resulted in the creation of the Leon Miller Trust Fund—this fund enabled the purchase of the sculptures from the shuttered Northland Mall.

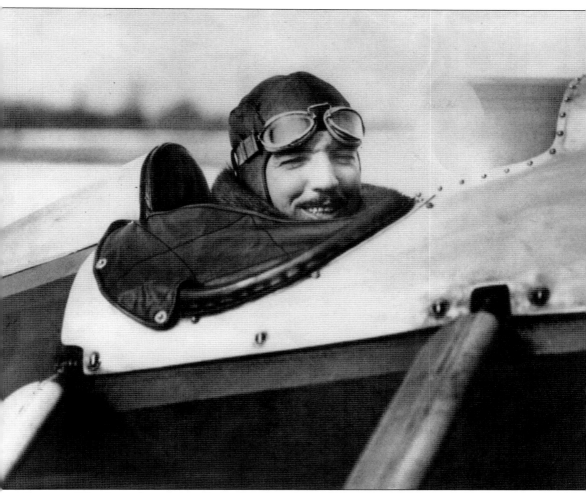

Born on Edge River farm near Telegraph and Twelve Mile Road in 1902, Harry Joseph Brooks attended elementary school in Southfield, later graduating from Baldwin High School in Birmingham (Southfield lacked a high school at that time). Brooks began working as a mechanic at an airstrip near Grand River and Orchard Lake Road in Farmington Township while simultaneously taking flying lessons. Brooks would go on to become Henry Ford's chief test pilot for the Ford Flivver, a lightweight one-seater plane. Ford had dreams of manufacturing a small plane that was affordable to average Americans and the Flivver was developed in furtherance of that goal. Brooks regularly flew the Flivver from the Ford Airport in Dearborn back to Edge River Farm. Harry's sister Blanche Brooks recalled his antics in an oral history conducted in 1989—when late for a speaking engagement, Brooks flew the plane to Detroit and landed on Woodward Avenue. Brooks is pictured here in about 1925.

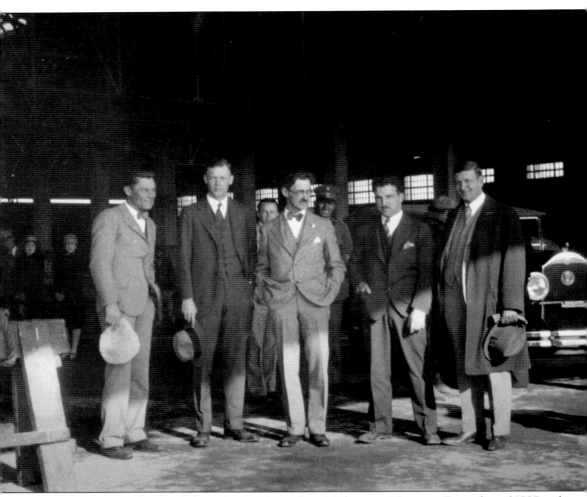

Brooks flew another Ford plane, the Tri-Motor, from Michigan to Mexico in December of 1927 and this trip garnered great publicity. He flew plane NC-1077 serial No. 10 on this trip, undertaken in order to escort Evangeline Lindbergh to Mexico so she could spend Christmas with her son Charles. This photograph was taken in Mexico City during that trip. Pictured from left to right are US ambassador Dwight Morrow, Charles Lindbergh, William B. Stout, Harry Brooks, and an unidentified Ford employee. Tragically, Harry died a few weeks later while trying to make a nonstop flight from Detroit to Miami. After failing to reach Miami, Harry stopped in Titusville, Florida for the night. On February 25, 1928, Harry took off from Titusville; however, shortly after takeoff, the Flivver went down off the coast of Melbourne, Florida. His body was never recovered, but a monument was erected for him in the Southfield Cemetery on Civic Center Drive.

Three

FROM AGRICULTURE TO SUBDIVISIONS

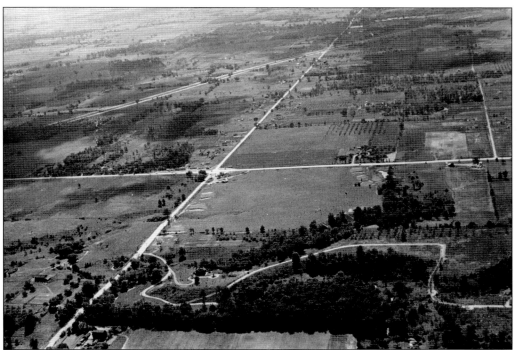

In 1934, farms and open spaces abounded in Southfield. This photograph looks west and shows the intersection of Twelve Mile Road and Telegraph in the midground. The two-lane road in the background is Northwestern Highway. The farm located in the extreme foreground is the Brooks family's Edge River Farm—the barn still stands today. The house on the winding road (Wildbrook Drive) in the midground is still standing today.

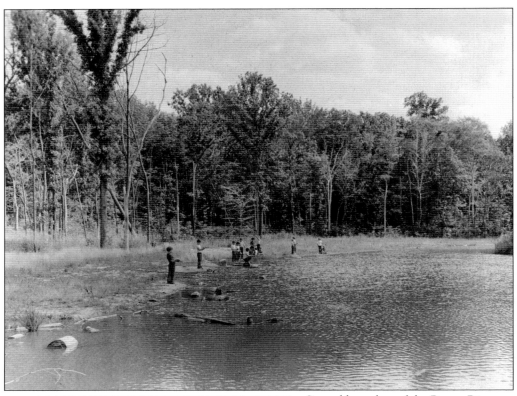

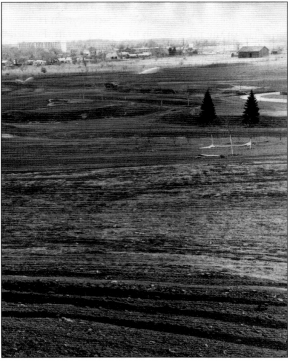

Several branches of the Rouge River run through Southfield. The river was an asset for early farmers who used it to access fresh water for their families and livestock. Early farmers recall the river regularly flooding, impeding traffic on Southfield's network of dirt roads. Later, the river became a backdrop for some of Southfield's most impressive mid-century homes. Children fish on the river in this undated photograph.

Taken around 1972, the construction of the Evergreen Hills Golf Course is underway in this photograph, and it shows the evolving landscape in Southfield: agriculture fields and barns sit beside newly built houses and office towers. The houses visible in the background are located on Filmore Drive and the barn on the right side is the barn on the Mary Thompson farm. In the background on the left, the Centrum Office Center (now the Mike Morse Law Firm) is visible.

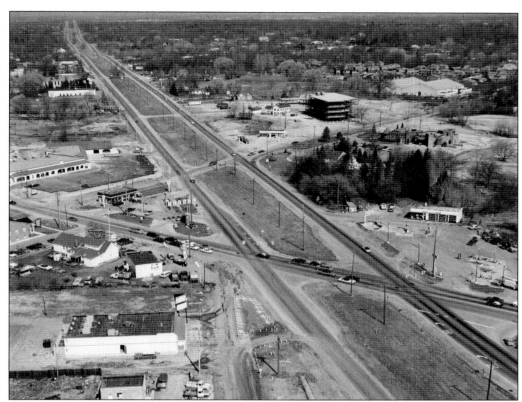

This photograph taken in 1974 shows old Southfield giving way to the new. Northwestern Highway (the two-lane boulevard) runs from the bottom right of the photograph to the upper left. Franklin Road runs through the middle ground of the image from the upper right corner while Twelve Mile Road runs through the image from the lower right. A large farmhouse (known in 1895 as Hickory Ridge Farm and owned by George Simmons) is seen in the center background standing directly beside the Franklin Place office center, under construction. The Vineyards restaurant is located directly across the street from Franklin Place.

Larrow Farms was located on Civic Center Drive just east of Northwestern Highway (the double-lane road running through this photograph). Founded in Cohocton, New York in 1890, Larrowe Milling Company moved its headquarters to Detroit in 1908. In 1920, Larrowe opened this 200-acre farm complex in order to test feeding regimens for cattle, poultry, and pigs. The farm tested the nutritional content of feeds and conducted studies on feeding programs and farm management. In 1929, General Mills purchased the research farm. General Mills sold the property to Lawrence Institute of Technology in 1952.

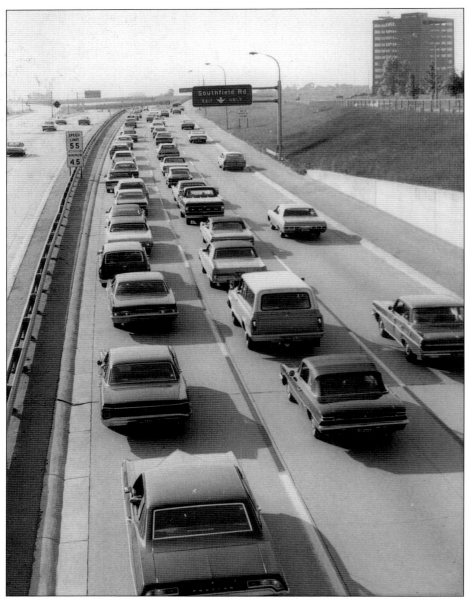

Cars rush down the Lodge Freeway in this undated photograph. The automobile is inextricably linked with the growth and development of Southfield. Detroit's network of streetcars and interurban railways did not offer service to Southfield. One line ran north up Woodward Avenue and another northwest along Grand River, however, neither went through Southfield. The Grand River line made stops in Sand Hill (roughly where Detroit's Old Redford neighborhood is today) and Clarenceville (in southeastern Farmington Hills today), but these stops were far south of Southfield Centre. To remedy the lack of public transit, the Detroit Street Railway began a bus route along Southfield Road to Birmingham in 1925. Nevertheless, a car was a near necessity if a family wanted to move to Southfield. As support for public transport waned in the mid-1900s and when the Federal Aid Highway Act passed in 1956, increasing emphasis was placed on the development of highways rather than public transit.

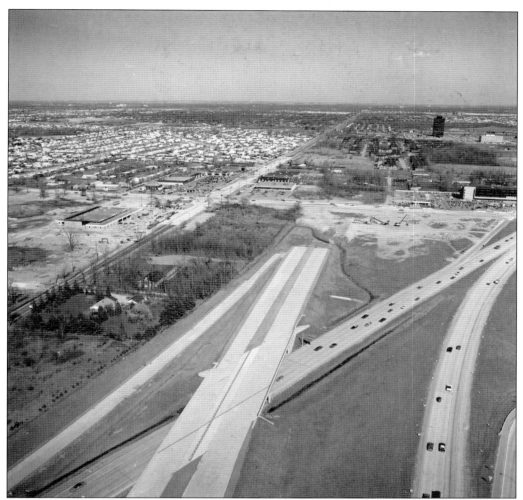

Running from Farmington Hills to St. Clair Shores Interstate 696 is a main east-west artery in southeast Michigan. Construction of Interstate 696 began in 1961—the western portion was completed in 1963 and the eastern portion was completed in 1979. The center section remained incomplete until 1989 as the routing through Southfield, Oak Park, Pleasant Ridge, and Royal Oak was embroiled in controversy in the 1960s. Southfield politicians, business leaders, and residents were particularly sensitive to this issue because, in 1965, Southfield had more land dedicated to freeways than any other city in the area. There were many proposed routes, however, a route along Ten Mile and a route along Eleven Mile were two of the hotly contested routes proposed in 1965. Southfield, Oak Park, and Pleasant Ridge all objected to the Ten Mile proposed route. The incomplete Interstate 696 extension at Lahser and Eleven Mile languishes, unfinished, in this 1974 photograph.

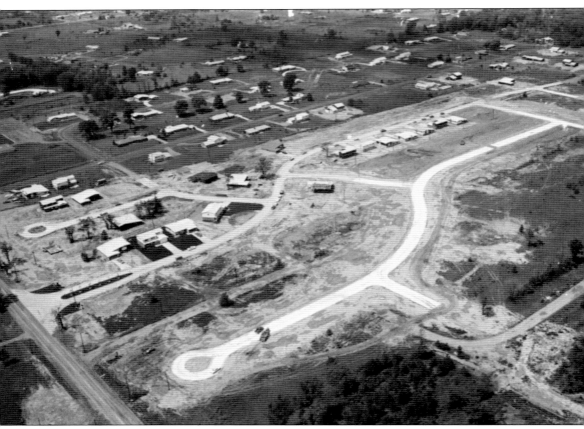

As Detroit grew, and with the proliferation of middle-class families who owned their own automobiles, suburbs like Southfield grew exponentially. In 1953, the *Four Corners Press* reported that Southfield had a banner year in terms of new buildings constructed. That year 1,541 building permits were issued, which was up from 1,467 in 1952 and 1,286 in 1951. Similar headlines graced the front page of the *Southfield News* in 1962 with 97 permits issued in April alone. The Sharon Meadows subdivision, located on 12 Mile between Lahser and Evergreen, is pictured above in the 1960s. The boulevard-like entrance and multiple cul-de-sacs are hallmarks of mid-century subdivision developments. In 1965, "the Tempo" model in Sharon Meadows was part of the Parade of Idea Homes showcase which allowed potential buyers to view various models in area subdivisions. The Tempo model was built by John F. Uznis Builders. (Courtesy of Walter P. Reuther Library, Archives of Labor and Urban Affairs, Wayne State University.)

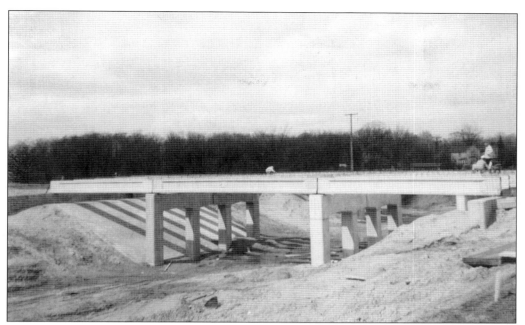

As Southfield grew and more rural areas were developed, infrastructure upgrades were necessary. Interstate 696 was begun in 1961 and was completed almost three decades later in 1989. The Interstate 696 bridge over Inkster Road is shown here under construction in 1962. The rural surroundings and an old farmhouse on Inkster Road are visible in the background.

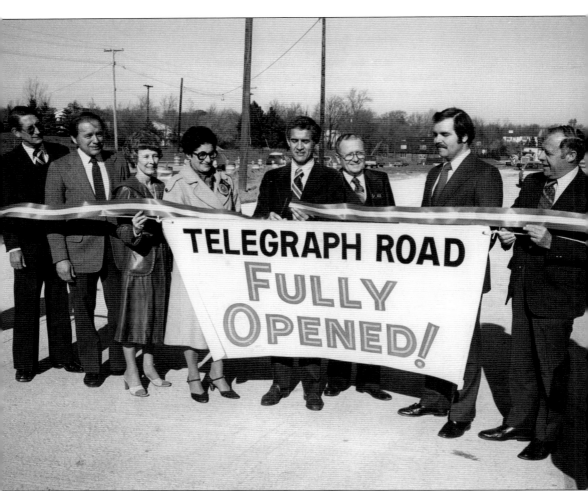

Telegraph Road bisects Southfield from north to south and, in its earliest iteration, was little more than a trail between fields. It likely acquired its name in the mid-nineteenth century as telegraph lines were built throughout the state. As telegraph wires were being installed, dirt access roads were built alongside the lines so they could be serviced. Telegraph Road began life as a telegraph access road and early photographs indicate it was little more than a two-track mud strip. It was later extended and improved throughout the late 1800s and early 1900s. Telegraph Road has long been a major commercial and industrial corridor in Southfield. A ribbon-cutting ceremony for the completion of Telegraph Road is shown here in 1979.

Four

INDUSTRY AND COMMERCE

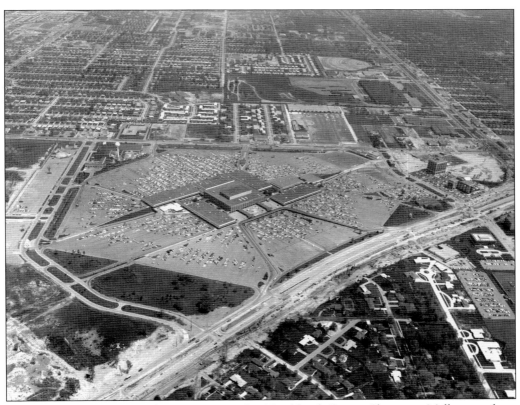

Developed by the J.L. Hudson Company, the Northland Center Shopping Mall opened on March 22, 1954, and is generally regarded as a turning point in retail history as it was one of the earliest suburban shopping malls ever built. Northland was featured in newspapers and magazines throughout the country including the *Wall Street Journal* and *Time*. The mall had 8,344 parking spaces and, at its peak, hosted 18 million shoppers annually.

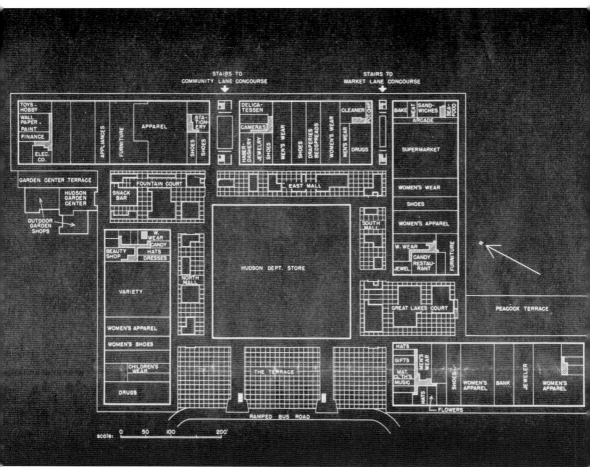

The layout of Northland shortly after opening. Designed by Victor Gruen, Northland was originally designed as an open-air mall with shops connected by courtyards and walkways. There were also extensive outdoor seating areas, a fountain court, large beds of flowers, and extensive artwork installations. When it opened, the center was anchored by a four-story Hudson's department store but also had a Himelhoch's, a Winklemans, an S.S. Kresge store, and a Sanders Confectionary. Many of the stores faced out toward the courtyards, set underneath a colonnade, which created covered walkways for shoppers to access shops during inclement weather. The courtyards and outdoor "halls" were carefully designed by landscape architect Edward Eichstedt with each outdoor space designed around specific planting schemes: the fountain court featured redbuds, rhododendrons, and azaleas while the Great Lakes Court had wildflowers and birches. Sculptures were located throughout the courtyards and, in the days before cell phones, provided easy places for a rendezvous during shopping trips.

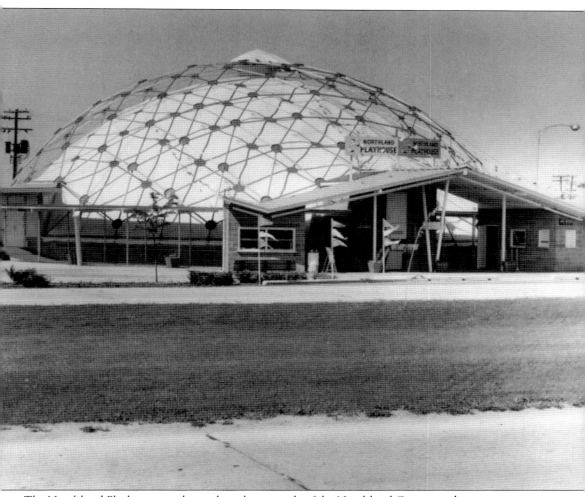

The Northland Playhouse was located on the grounds of the Northland Center, and upon opening in 1956, was comprised of a tented structure with 1,550 seating capacity. After the tent was blown down during a windstorm, a geodesic dome was constructed in 1957—seating just 1,000—to create a more permanent venue. The resident theater director in 1958 was Lloyd Richards who became the first African American to direct a Broadway production (*A Raisin in the Sun*) in 1958. Richards went on to win a Tony Award for directing *Fences* in 1987. The playhouse featured other stars, including Mae West, Zsa Zsa Gabor, Diana Barrymore, Tallulah Bankhead, and James Coburn. Despite high-quality Broadway productions with Hollywood stars on the stage, the playhouse held its last summer season in 1966. In December 1966, the dome was reimagined as the Mummp, a nightclub for teenagers. The club opened with the Shy Guys, Tidal Waves, Gino Washington, Tim Tam, and the Jagged Edge playing.

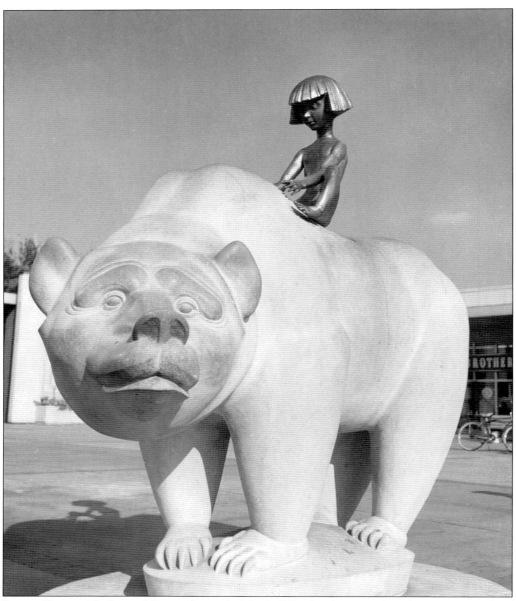

Pictured here is *The Boy and Bear* sculpture by Marshall Fredericks, created in about 1954. Made of sandstone and gilded bronze, this statue was a star attraction in the Northland Center. Fredericks was born in Illinois, raised in Cleveland, and later taught art at the Cranbrook Academy of Art and the Cranbrook and Kingswood Schools in Bloomfield Hills. In addition to *The Boy and Bear*, Fredericks also designed the Wayne County seal, the Spirit of Detroit statue, and the Fountain of Eternal Life in his hometown of Cleveland, among many other famous commissions. When the Northland Center closed in 2015, the City of Southfield, interim Southfield mayor Donald Fracassi, and the then-councilman Ken Siver raised money and arranged a low-interest rate loan for the purpose of buying and restoring a portion of the art collection at the mall. *The Boy and Bear* sculpture in particular is beloved by Southfield residents and is now installed in the vestibule of the Southfield Public Library.

The *Moby Dick* sculpture from Northland was created by American sculptor Joseph Anthony McDonnell. The J.L. Hudson Co. commissioned the sculpture, and it was located in a courtyard in the mall prior to its closing in 2015. Refurbished after Southfield city officials raised money for repairs, the sculpture is now located in a fountain outside the Southfield Public Library.

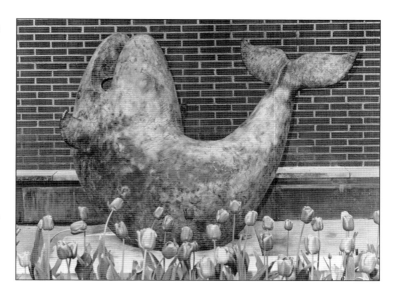

Northland went through a renovation campaign in the 1970s and was enclosed in 1974–1975. Through the 1980s and 1990s, as shopping habits began to change, the mall experienced high turnover. Macy's, a successor of Hudson's, closed its doors on March 22, 2015, exactly 61 years after it opened to much fanfare in 1954.

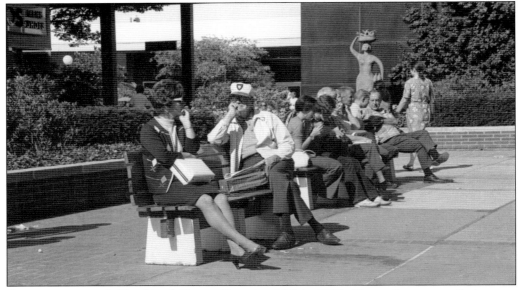

Shoppers sit outside Northland Center Shopping Mall in 1971. The mall was a small city unto itself with a Kroger's grocery store, a bank, a post office, an infirmary, and an auditorium. The Kroger store featured an underground conveyor belt that delivered customers' groceries to a parking lot terminal for easier pickup. Much like the City of Southfield itself, Northland Center's growth and success were built upon the automobile as Americans embraced suburban life. (Courtesy of Gary Karp.)

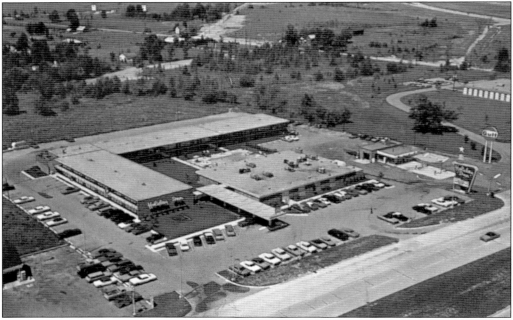

The Holiday Inn hotel is shown here in an undated postcard. This Holiday Inn was built on Telegraph Road just south of Interstate 696. When it opened the hotel had 120 rooms, a dining room, and a cocktail lounge called the Red Wing Tavern. A 104-room addition was added in 1970. (Author's collection.)

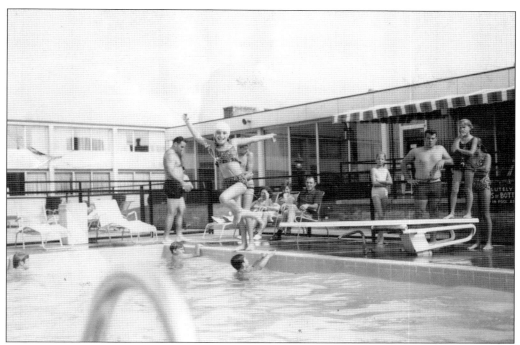

Children play at a hotel pool in this undated photograph. As Southfield developed and more freeways were built, new businesses and modern hotels were strategically located along these thoroughfares. The Holiday Inn chain in particular embraced incorporating swimming pools into their hotels as they catered to traveling families.

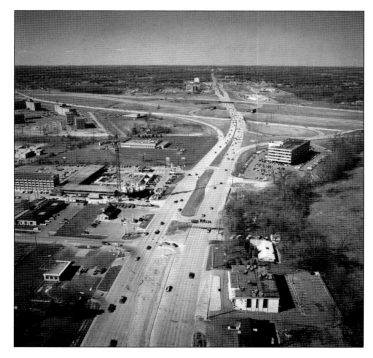

In 1974, the Holiday Inn added a large circular tower to their hotel property on Telegraph Road. The tower is under construction in this photograph. In the 1970s, Holiday Inn began building round towers across their portfolio of properties and these circular high rises became synonymous with the Holiday Inn brand during this era. At the top of the Southfield Holiday Inn was a revolving restaurant—a feature employed at other round Holiday Inns as well. In 2013, one source suggested only 15 round Holiday Inn towers remain in the United States.

The Vineyards restaurant was located in Southfield at Franklin Road and Northwestern Highway. With arched and vaulted stone ceilings, the interior was reminiscent of a castle which stood out to diners who remember going there during its heyday. Serving upscale dishes like lamb stew, steaks, and seafood, the restaurant was a destination for engagements, receptions, and other milestone events for local residents. The slow-cooked pork roast was a particular specialty. Owned by Fred Graczyk, the restaurant had a "Bastille" room with a piano bar in the basement. Musicians Bess Bonnier, Mickey Stein, Matt Michaels, and Jack Brokensha were regular performers in the basement bar. By 1980, John Laffrey took charge of the restaurant, updated the menu, and slightly modernized its "medieval dining hall" décor. The building was torn down sometime after 2007. (Author's collection.)

Michael C. Wietecha founded Wietecha Monument Company in 1947 on Ten Mile Road, just east of Beech Road. Third and fourth generations of the Wietecha family still run the company. In addition to the main Southfield location, the Wietecha family also has a store in Detroit at 22602 West Warren Avenue. Michael is shown here carving a monument in the 1930s or 1940s. (Courtesy of the Wietecha family.)

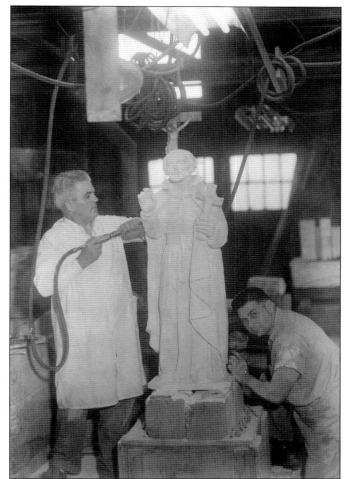

The Wietecha Monument Co. started from this small building—shown here just after its construction in 1947—and has expanded since then. Since its founding, Wietecha Monument Company has continued to provide markers, monuments, headstones, and other related products from both of their locations. (Courtesy of the Wietecha family.)

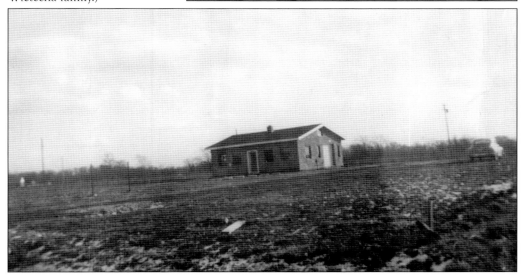

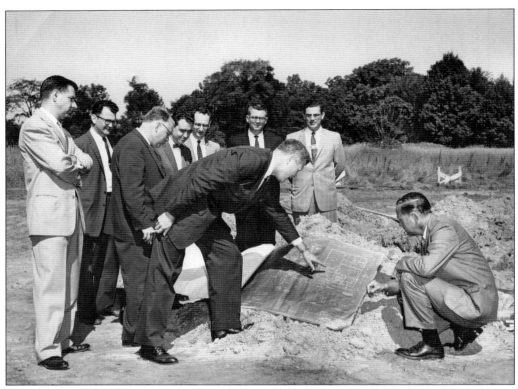

Men from the Bendix Corporation examine architectural drawings for their new facility in Southfield. Bendix was founded in Moline, Illinois, to produce electric starting motors for automobiles. Bendix first moved to Southfield in 1956 when it relocated its research labs from Detroit to a new 80,000 facility at the corner of Northwestern Highway and Civic Center Drive. Bendix built a new executive office on their Southfield campus in 1967.

City officials and Michigan Bell Telephone Company representatives line up outside the new Michigan Bell office in Southfield in 1962. Michigan Bell was a local exchange carrier that was a part of the Bell System broken up in 1983 due to antitrust issues. Pictured at the extreme left is Jim Clarkson, mayor of Southfield, while city councilwoman Jean McDonnell is fifth from left.

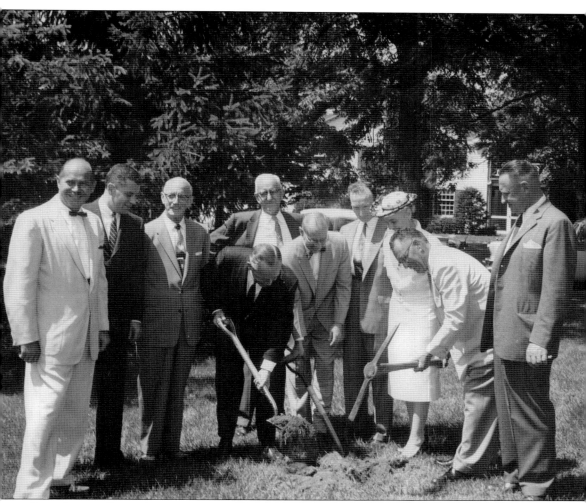

One of metro Detroit's most recognizable local media outlets, WXYZ was founded in 1925 as WGHP. Here, in 1958, officials break ground on the new WXYZ radio and television studio on Ten Mile Road. From left to right are John Pival, Hal Neal, Robert Wuerfel, James G. Riddell (with a shovel), Eugene Swem (behind Riddell), Donald Swanson (with a shovel), Patrick Flannery (beside Swanson), Jean McDonnell, Neil McGregor (with a pickaxe), and E. Christensen. Opened in 1959, the new facility cost $4 million but utilized the historic McKinny House on the grounds of the station's property. Also known as the Beardslee House and the Nelson farm, it was built around 1850 by James McKinny and was reportedly renovated to serve as a cafeteria for WXYZ employees. Southfield has been a hub of television and radio broadcasting since WXYZ opened, and the studio and station equipment are still located on Ten Mile Road today.

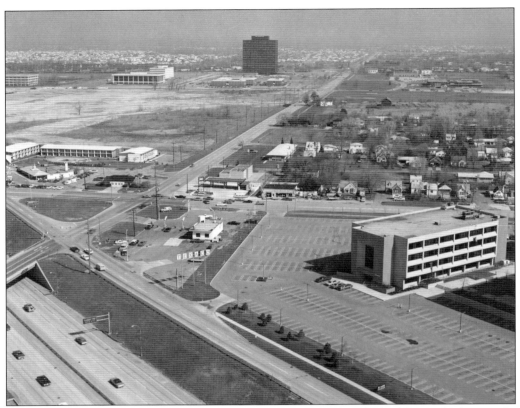

The intersection of Evergreen and Ten Mile is shown here in 1974. The building at the lower right is currently used by the Northwestern Technological Institute; however, upon opening in 1969 the building housed various insurance and investment firms including Goodbody & Co. and Southfield Underwriters, Inc. Visible in the midground on the upper right is Mary Thompson's farmhouse and barn while the Southfield Civic Center is the upper right background. On the left in the midground, the Southfield Fire Station is located at the corner of Evergreen and Ten Mile Roads while Howard Johnson's hotel and restaurant (with the white roofs) is beside it.

Merrill Lynch, Pierce, Fenner & Smith, Inc. moved to a new office in Southfield in 1969. Located at 26250 Northwestern Highway, the building contained the latest in communication and investment trading technology. An advertising brochure published by Merrill Lynch touted the facility's "jet age service."

48

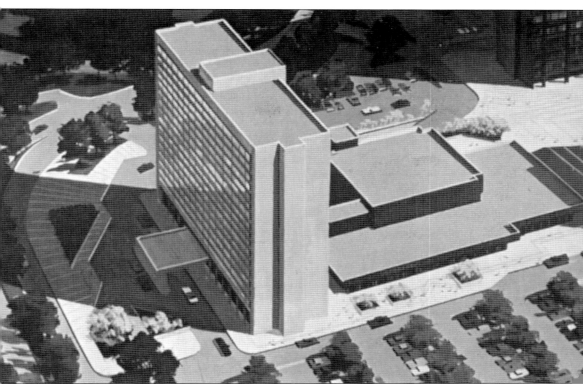

The Shiawassee Hotel is shown here in an undated rendering. The hotel was designed by the architecture firm King & Lewis who also designed the Hotel Pontchartrain in Detroit, the Lafayette Park Shopping Center in Detroit, the Dearborn Towers in Dearborn, and the Nelson Towers in Jackson, Michigan. Located at 17017 West Nine Mile Road, the Shiawassee Hotel was advertised as "the finest, largest and most luxurious hotel in Michigan." Opened in January 1974, the hotel boasted 400 rooms and three restaurants including the Au Sable Room, the La Salle Lounge, and the Butcher Block Coffee Shop. However, from the outset, the hotel suffered from operational difficulties and faulty design. Just a year after opening, Sheraton was brought on to operate the hotel and they planned to extensively upgrade and refurbish the building. The building later cycled through additional owners, and it was torn down in 2014.

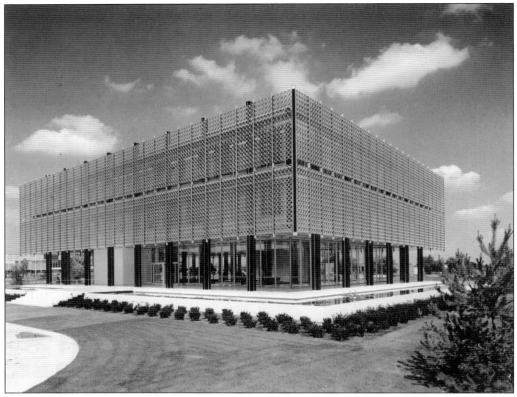

The Reynolds Metal Sales Office is one of the most important modern-style buildings in Southfield. Designed by famed architect Minoru Yamasaki, who lived and worked in Michigan for much of his life, the building was completed in 1959. Clad in a decorative aluminum screen and surrounded by a reflecting pool that was filled with water lilies, the building was lit by floodlights creating a dramatic architectural vision at night.

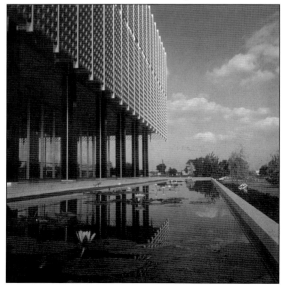

The Reynolds Aluminum Regional Sales Office was called "a glimmering jewel" when it opened in 1959. The building was intended to showcase aluminum in various diverse applications. The reflecting pond on the exterior, a Yamasaki signature, is shown here. (Courtesy of the Balthazar Korab collection, Library of Congress.)

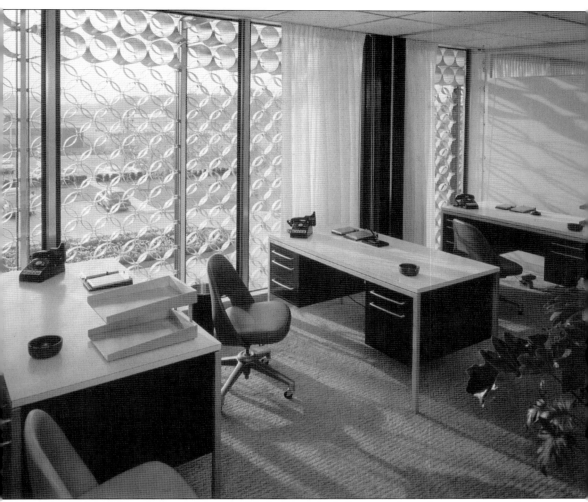

The interior office spaces of the Reynolds building had floor-to-ceiling glass windows, which were set behind the decorative aluminum screen. The offices benefited from Yamasaki's cleverly designed exterior screen because the screen, made up of interlocking gold-toned aluminum rings, was designed to shield the office occupants from the sun's rays until the sun sank to a low level. Yamasaki also designed a screen for the entry doors at the McGregor Memorial Conference Center on Wayne State University's campus. Yamasaki was one of the most important architects of the 1960s, appearing on the cover of *Time* magazine in 1963. Yamasaki designed some of the most architecturally interesting and significant buildings in the United States, including the Lambert Airport Terminal in St. Louis, the World Trade Center in New York City, and the Rainier Tower in Seattle. (Courtesy of the Balthazar Korab collection, Library of Congress.)

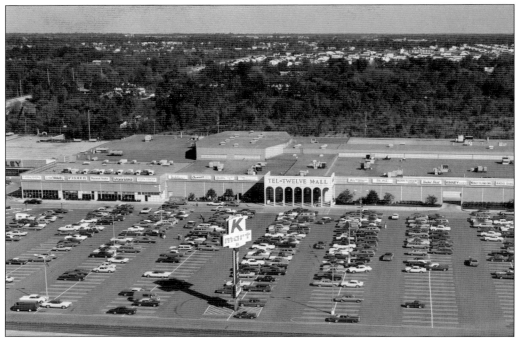

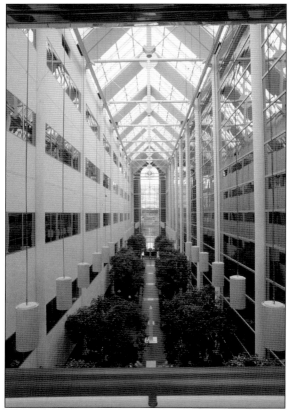

Located at Telegraph and Twelve Mile Roads, the Tel-Twelve Mall was designed by prominent local architect A. Arnold Agree. Advertisements upon opening in 1968 touted the fact that Tel-Twelve was a completely enclosed climate-controlled shopping destination. The atrium was carpeted with Astroturf and had an indoor fountain.

In 1973, Southfield had 11.3 million square feet of office space but a correspondingly high vacancy rate of 29 percent. However, office building development continued into the 1980s. The central atrium of the Galleria Office Center is shown here in this 1988 photograph. Designed by Kenneth Neumann & Associates, the building cost $27 million and opened in 1983. (Courtesy of the Balthazar Korab collection, Library of Congress.)

Five

EDUCATION

By 1872, Southfield had district schools 1–10 spread throughout the township. This 1895 map shows the districts along with the fractional districts that encompassed most of the northern part of Southfield Township. Fractional school districts were schools that contained land from more than one township—in this case the fractional districts 1, 2, and 3 on this map contained land from both Southfield Township and Bloomfield Township to the north.

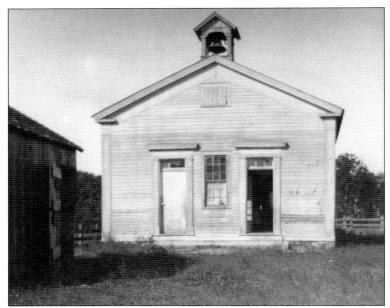

The Beddows-Brooks School was one of the earliest schools in Southfield, reportedly built in the mid-to-late-1830s. Before this school was built some Southfield children attended school in Franklin Village, which was, at that time, part of Southfield Township. This photograph is undated, but it shows the school before it was clad in brick, which occurred after the district was consolidated in 1947.

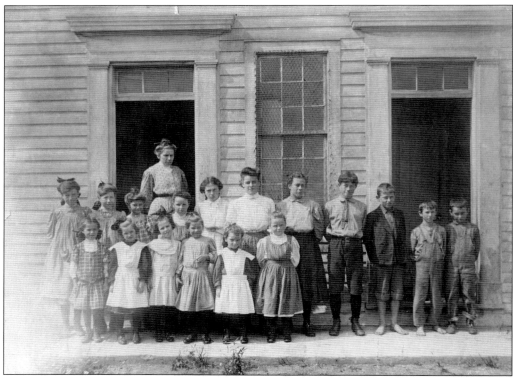

Schoolchildren and their teacher, Maggie, line up outside the Beddow School in this 1908 photograph. It was originally named for the Beddow family who donated the land upon which it was built. Sometime around 1930, it was renamed for the prominent Brooks family of Southfield. As seen in this photograph, schools of this era often had two entrances—one for male students and one for female students.

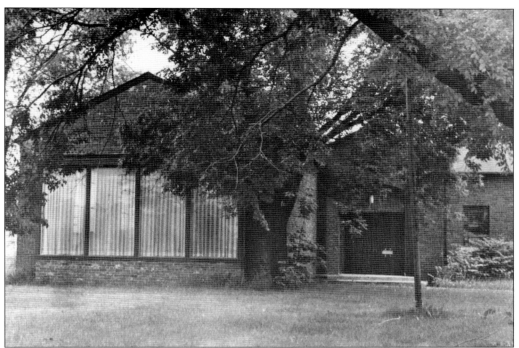

The Beddow-Brooks School as it looked in the 1960s. The building is highly altered from its original appearance with an addition, brick cladding, and a large picture window. School functions ceased in the 1950s. From 1960 to 1962, it housed Southfield's first public library. The building was later used by the school district and as a credit union. In 1983, it was converted to use as a bus terminal.

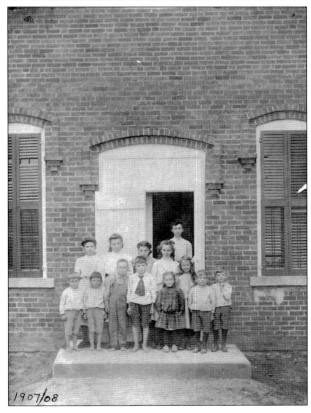

The Klett School is pictured here in 1907–1908. The school was located on the Klett family's property at Nine Mile and Beech Roads, but it was also known as School No. 9. A map from 1872 shows School No. 9 was located on the east side of the section line. However, a map from 1895 places it on the west side of the section line, across from the Klett property. The Klett family property was later sold to the City of Southfield to be developed into Beech Woods Park.

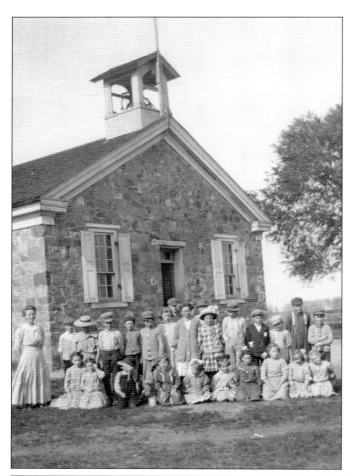

The Old Stone School was the schoolhouse located in district No. 10. It was located at the corner of Berg and Ten Mile Roads, primarily educating children from the Jenks and Sturman families. The school is shown here in 1910 or 1911.

Children enjoy recess at the Old Stone School. Before consolidation, early elementary and middle school students from Southfield had no option for high school unless they paid tuition and traveled to communities like Farmington, Royal Oak, and Birmingham (among others) to complete their education.

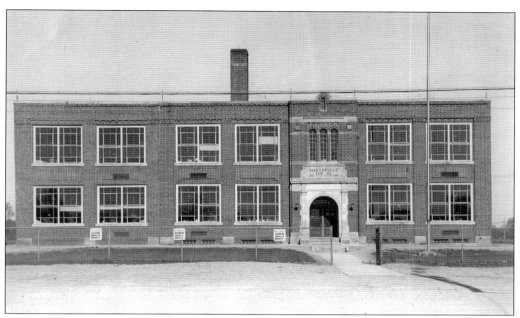

The Southfield School No. 10 shown here was built in 1928 and replaced the Old Stone School. When completed, this school had five classrooms including one in the basement. In 1940, three more rooms were added. More additions were completed in 1950, 1954, and 1967.

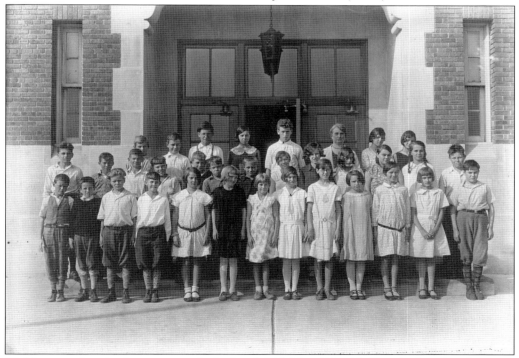

Children stand in the doorway outside the Southfield School No. 10. Heavily altered in the 1980s for use as the Vanguard office building, the distinctive stone and brick entrance was retained on the west façade of the new building.

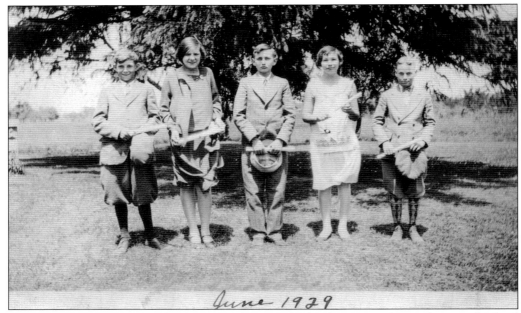

The eighth-grade graduating class of the Angling Road School in 1929. The Angling Road School was located on Franklin Road (appropriately, a road that angles in a northwesterly direction) and is district No. 6 on the map shown at the beginning of this chapter. Shown here are Walter Douglas, Ruth Fenningdorff, Charles Roediger, Charlotte Roediger, and Hamilton White.

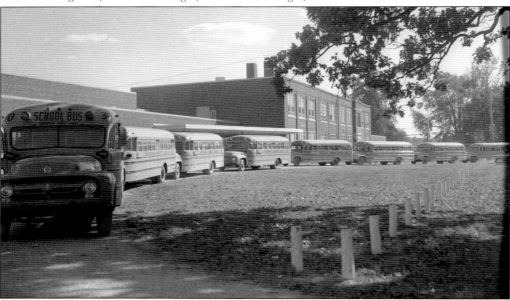

School buses line up outside of a Southfield school in 1956. The Southfield Township School District was created in 1947 by consolidating the township schools scattered throughout the district. In 1947, the consolidated district had just five buses; however, more were purchased that summer. With consolidation came the need for a high school, which Southfield did not have at that point. (Courtesy of Walter P. Reuther Library, Archives of Labor and Urban Affairs, Wayne State University.)

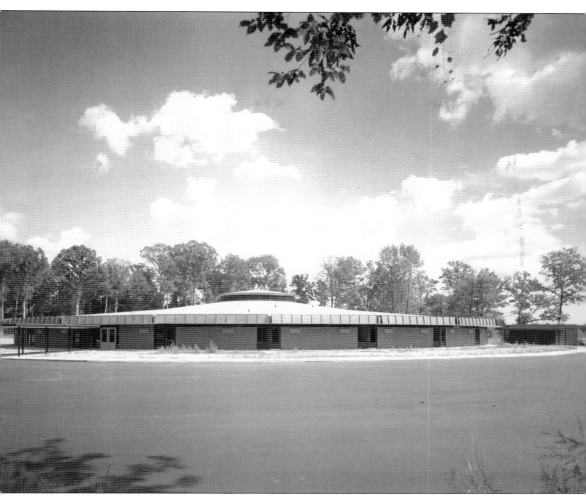

MacArthur Elementary School is shown here in 1966 shortly after completion. As Southfield grew in the 1950s and 1960s, the city had to build more schools to accommodate the burgeoning student body. The round-shaped school cost over $1 million to build and was designed by architect Joseph St. Cyr from Livonia. His firm St. Cyr Architects & Associates were noted local designers of many schools, churches, and office buildings including St. Martin de Porres Church in Warren, the Adams School in Wayne, the Franklin School in Wayne, the Fillmore School in Warren, and the Davis Jr. High School in Utica. The circular design of MacArthur contained 20 classrooms and was touted as being advantageous for heating and cooling, being that it had less corridor area. At the center core of the building, the school had a large, half-circle multi-purpose room, administrative offices, and a large, open instructional materials center. Today, the building is used as the Bussey Center for Early Childhood Education. (Author's collection.)

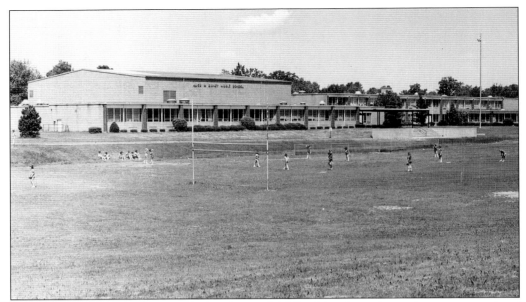

Children on the athletic fields of Alice Birney Middle School are shown here in an undated photograph. Designed by O'Dell, Hewlett & Luckenbach, the school was built in 1957 with an addition in 1965. Located at 27225 Evergreen Road, it was named after a New York woman who founded the National Parent-Teacher Association (PTA).

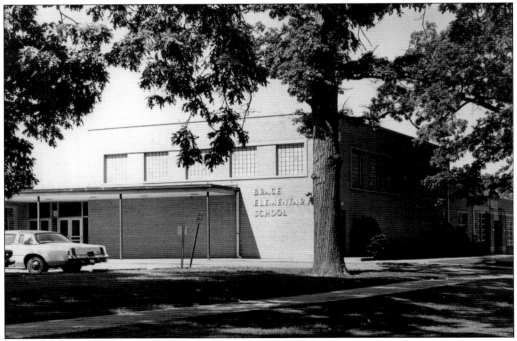

The Brace Elementary School is shown here in an undated photograph. Most recently called the Brace-Lederle Middle School, the name Brace comes from the farming family who used to live on this property, and the name "Lederle" comes from a former county superintendent of schools. The school was closed in 2017.

The Morris Adler Elementary in an undated photograph. Built in 1967, the school was named after Rabbi Morris Adler in 1968 who was the spiritual leader of the Congregation Shaarey Zedek before his assassination in 1966. Since the 1950s, Southfield has had a vibrant and thriving Jewish population and the assassination of Rabbi Adler was devastating to the local community.

The Lawrence Institute of Technology's Science Building is shown here in a 1974 photograph. Commonly known as Lawrence Tech, the school has been located in Southfield since 1955. The school started in Detroit as an undergraduate institution but later added graduate classes and departments in architecture, management, and other technological fields.

61

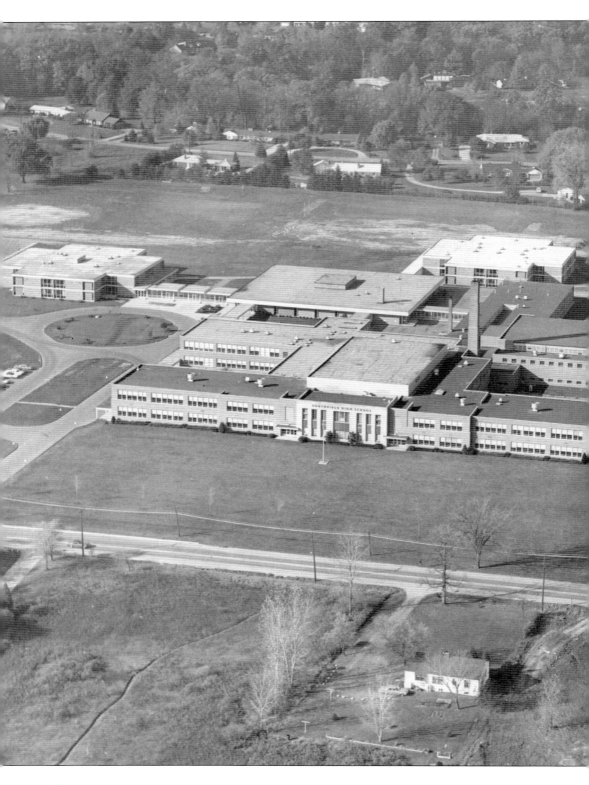

Southfield High School is shown here in this undated photograph. Now known as the Southfield High School for the Arts and Technology, the school was built in stages over 10 years from 1949 to 1959, with additional alterations in later years. The first portion of the building was dedicated in 1953 and served 1,201 students; however, the building was not finished, and Southfield High School would eventually feature two art rooms, a communications center with turntables, a greenhouse, a publications center, and a six-lane 75-by-42-foot swimming pool with an additional 25-by-25-foot area for diving. Southfield's second oldest high school, Southfield-Lathrup High School closed in 2016 and students from Southfield-Lathrup were split between Southfield High School and the University High School Academy.

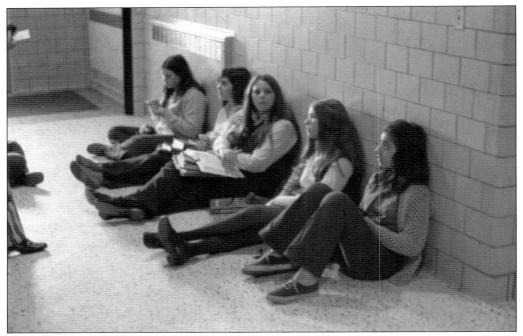

Students at Southfield High School sit in the hallway in this 1971 photograph. Southfield grew exponentially in the 1950s. In ten years, enrollment swelled from zero high school students in 1947 to 1,360 by 1957. Southfield High School was designed by Jensen & Keough, a firm well-known in southeast Michigan for several other school designs. (Courtesy of Gary Karp.)

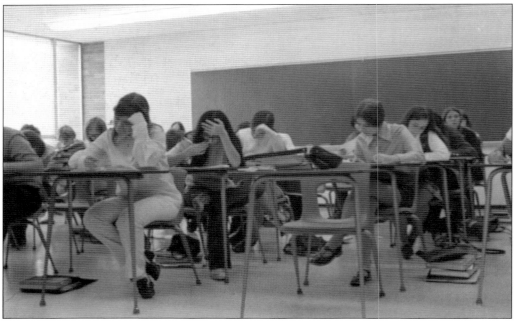

A typical classroom scene in Southfield High School in 1971 is shown here. In the 1970s, it was estimated that 75 percent of the graduating classes went to college; however, that rose to 88 percent by 1991. (Courtesy of Gary Karp.)

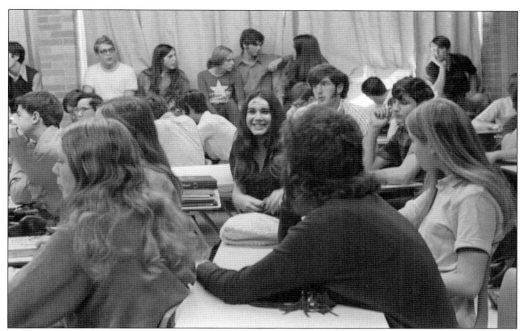

Bonnie Lipsen smiles in this photograph taken at Southfield High School in 1971. The boy to her left is Rick Moscow, and, beside him, is Michael Klaiman. In the background, Cindy Mahlin (shirt with a star) sits next to Marshall Mandell. (Courtesy of Gary Karp.)

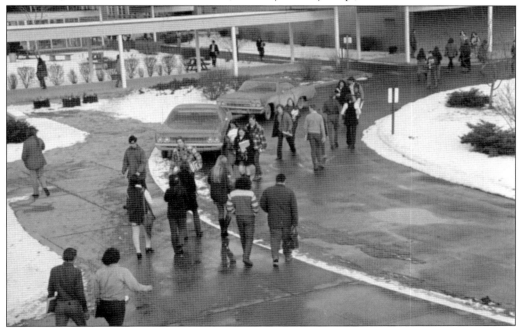

Southfield High School students walk to class in this photograph taken in 1971. Built at a cost of $1.7 million, Southfield High School had an extensive A/V and radio equipment room, a library with balconies overlooking the reading floor, and a modern home economics lab with five kitchen areas. (Courtesy of Gary Karp.)

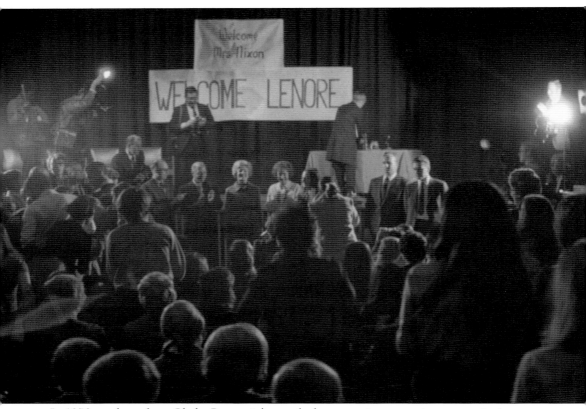

In 1970, students from Gladys Bernstein's speech class were given an assignment to invite someone to school for an interview. One of the students, Lisa Roth, invited Lenore Romney (former first lady of Michigan when her husband, George Romney, was governor) because she was running for the US Senate. Lenore agreed to come, and she brought a guest who turned out to be First Lady Pat Nixon. Thus, the school decided to turn it into a school-wide event. Reportedly over one thousand students attended the event in the school's auditorium where Romney spoke to students about her campaign, and Mrs. Nixon accepted a replica of the school's flag. The campaign stop at Southfield High School was successful, but Romney later lost her bid for the US Senate seat to incumbent Democratic senator Philip A. Hart. (Courtesy of Gary Karp.)

Six

Religion

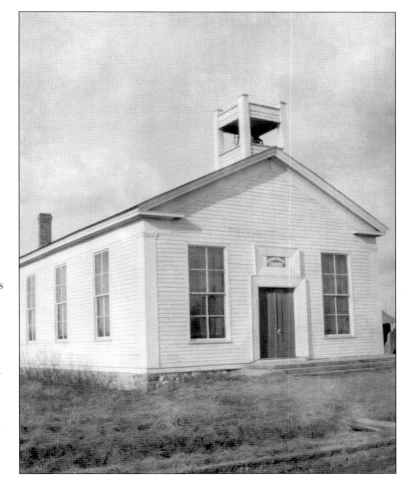

The Methodist Church was completed sometime around 1854–1856 and was originally located on Ten and a Half Mile Road in the old town center. Local farming families came together to construct the church under the direction of John Delling. The church was moved to its current location in the "historic village" known as the Burgh in the 1980s. Today, the church is used for city functions and is available for rent for events.

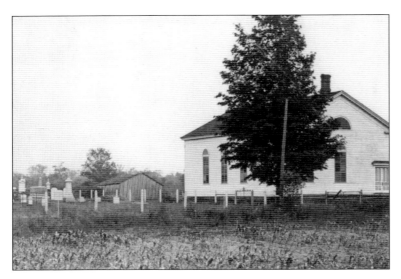

The Southfield Reformed Presbyterian Church (also known as Covenanters Church), located at 26550 Evergreen Road, is Southfield's oldest. This photograph was taken around 1918. Originally organized in 1834, local pioneers established the church and initially worshipped in area homes. This building was constructed in 1861.

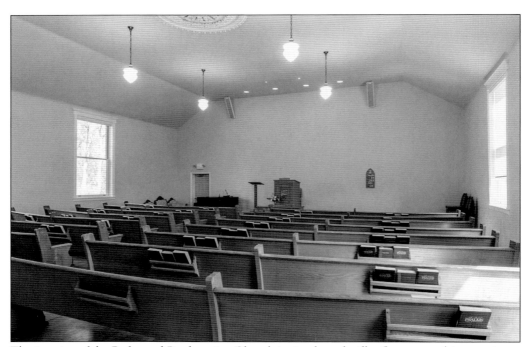

The interior of the Reformed Presbyterian Church is simple and still reflects a worship experience many of its first attendees would recognize. Rev. James Neill was the first pastor, serving from 1842 to 1851. Rev. J.S.T. Milligan was the second pastor, and he was an ardent abolitionist. This church was nominated and recognized on the Network to Freedom Trail in 2023 for its significance to the abolitionist movement. (Author's collection.)

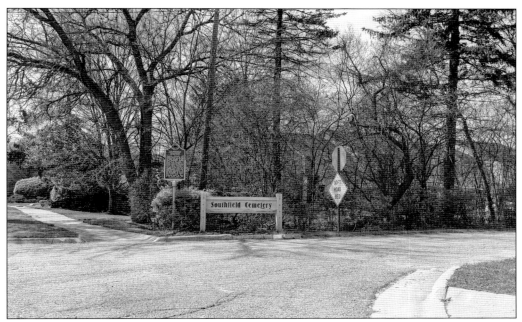

The Southfield Cemetery is located on Civic Center Drive and was established around 1833. Land purchased from Thaddeus Griswald for $8 would later be enlarged by additional land purchases in 1847. Located just east of the old town center, many early settlers of Southfield are buried here including members of the Fuller, Stewart, Sturman, Jenks, Bell, and Sherman families. (Author's collection.)

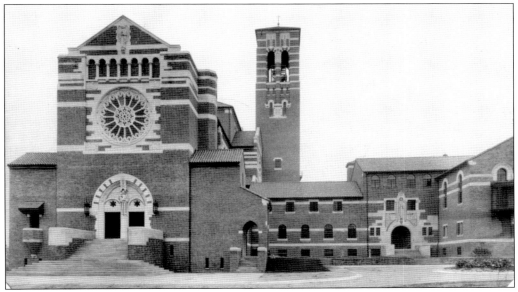

Southfield was home to Duns Scotus College from its founding in 1930 to 1979. The Franciscan Province of St. John the Baptist purchased 117 acres of land at the corner of 9 Mile and Evergreen Roads to build a college seminary for the training of monks. The ground was broken in 1928 and the original college buildings were designed by Wilfrid Anthony. Today, the campus is used by the Word of Faith International Christian Center. (Author's collection.)

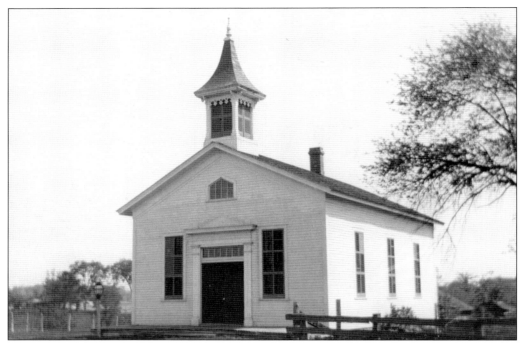

The Southfield United Presbyterian Church located at 21575 West Ten Mile Road was organized in 1850. The Greek Revival-style church seen here was built in 1862. Later, additions were constructed in 1953 and 1960. Today, the church is home to the Kingdom Builders Christian Church.

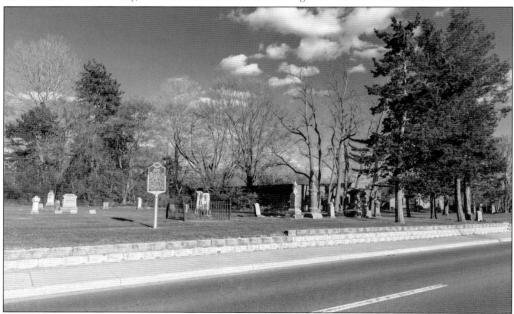

The Pioneer Cemetery is located on Lahser just south of Civic Center Drive. The second oldest known cemetery in Southfield, the Pioneer Cemetery was established in 1837 near the location of the old Crawford Corner's settlement at the intersection of Lahser and Ten Mile Roads. (Author's collection.)

This Presbyterian Church was located just south of Pioneer Cemetery in the old "Crawford's Corners" settlement at Ten Mile and Lahser. John and Ann Thomas donated the land for Pioneer Cemetery to the Congregational Church of Southfield in 1837. It is believed the church was built around the same time. According to longtime township clerk Fannie Adams, the church "disappeared" sometime around 1920.

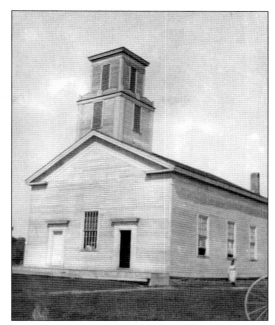

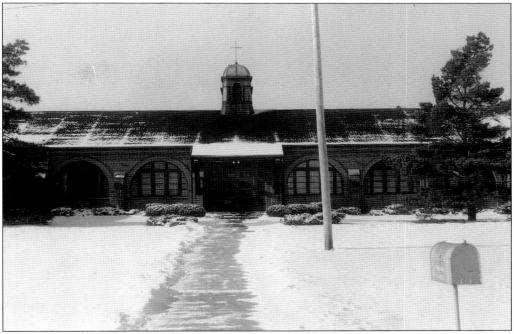

In addition to its many public schools, Southfield also has had many private and religious schools. By the 1980s, Southfield had the Alex Manoogian School, the Southfield Christian Academy, St. Michael's School, Midrasha-Hebrew, St. Bede's, and Alice and Julius Rotenberg Yeshivath Beth Yehudah. Pictured here is the St. Michael's School in 1973. St. Michaels opened in 1947 and served 368 families. In 2007, the four Southfield parishes of St. Beatrice, St. Bede, St. Ives, and St. Michael were merged into one new parish at the former St. Michael facility on Ten Mile and Code Roads. The new parish was named the Church of the Transfiguration.

The Holy Sepulchre Cemetery was opened in 1928. As the Catholic population in Detroit grew, the diocese of Detroit bought 357 acres on West Ten Mile Road to relieve crowding in the Mt. Olivet and Mt. Elliott cemeteries. Improvements costing $1.5 million were scheduled under the direction of landscape architects and planners T. Glenn Phillips and H.A. Lamley. The property was located along the Rouge River and included gently rolling hills which were enhanced by the damming of the river to create Lake Genesareth. Five miles of roads were constructed, and a chapel mausoleum was built—the chapel was staffed by monks from Duns Scotus who performed religious services in the building. Sales of the lots in Holy Sepulchre were used to partially fund the construction of the Archdiocese's Cathedral of the Most Blessed Sacrament in Detroit, which was completed in 1930. (Author's collection.)

The architectural rendering pictured here was done for the Synagogue for the Congregation Beth-Achim historically located at 21100 West Twelve Mile Road. Designed by Detroit-based Louis G. Redstone, the building was decidedly modern in style with a concrete column loggia at the main entrance, copper-clad domes atop the entrance loggia, and a copper-clad projecting bow at the gable of the main sanctuary. Redstone was one of Detroit's most famous modernist architects having also designed the Michael Berry International Air Terminal at the Detroit Metro Airport, the Manufacturers Bank Operations Center, the Macomb Mall in Roseville, the Wonderland Mall in Livonia, and the Business Administration Building at Lawrence Technological University, among other important commissions. In addition to his design work as an architect, Redstone was also an accomplished artist. In 1999, the Beth Achim building was sold to the United Jewish Foundation; the building was demolished in 2017.

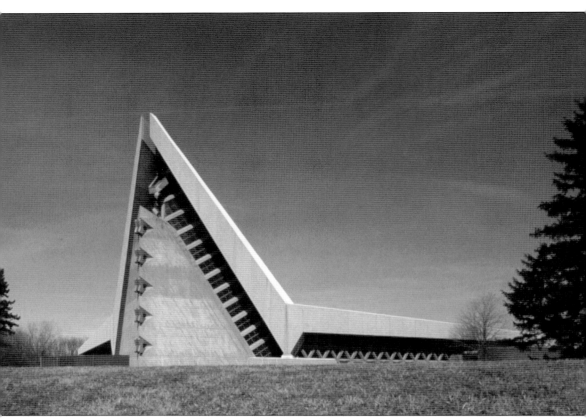

In the early decades of the 20th century, Detroit had a thriving Jewish commercial district centered around Broadway Street—many first-generation Jewish families from Germany and Central Europe lived in the Hastings Street neighborhood which was on the near east side of downtown Detroit. However, the overcrowding in the near east side neighborhood around Hastings Street prompted Jewish Detroiters of means to begin moving north and west of downtown. The move from Hastings Street to neighborhoods in northwest Detroit (like the area around Twelfth Street, the Dexter neighborhood, and Russell Woods) accelerated in the 1920s–1930s. By the 1950s and 1960s, many Jewish families were moving to Southfield; in 1986, it was estimated that half of the metro Detroit area's Jewish population lived in Southfield and Oak Park. Picture here, Congregation Shaarey Zedek is one of the most architecturally impressive religious buildings in Michigan if not the country. Designed by Percival Goodman who worked in conjunction with Albert Kahn and Associates, the cornerstone of the new building was laid in 1962 with Rabbi Morris Adler officiating. (Courtesy of the Balthazar Korab collection, Library of Congress.)

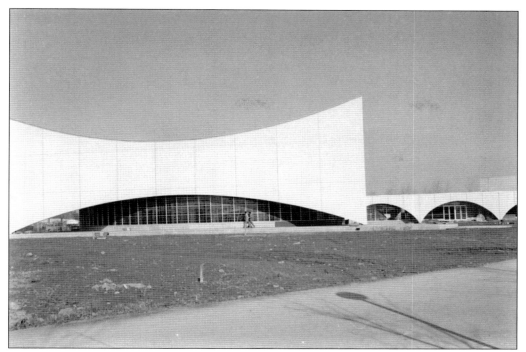

The former location of the Congregation B'Nai David Synagogue was completed in 1959 and was designed by Jewish architect Louis G. Redstone. The Congregation B'Nai David sold the building in 1993 to the City of Southfield. Sold again in 2003, today the building is owned by the Moslem Shrine which operates the building as the Silver Garden Events Center. (Courtesy of Walter P. Reuther Library, Archives of Labor and Urban Affairs, Wayne State University.)

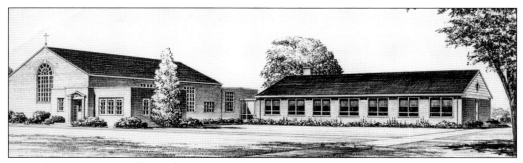

Located at 18140 Cornell Road, the Church of the Redeemer, part of the Episcopal Diocese of Michigan, celebrated its 50th year in 2008. The rendering here is dated 1959. The church hosts an Episcopal Church women's club, men's fellowship, and Compass Club, along with dinners and other organized programs.

Southfield has a long reputation as a city that has welcomed people of all races, faiths, and denominations. The Divine Providence Lithuanian Catholic Church at 25335 West Nine Mile Road was constructed in 1972 and continues to be a center of spiritual and social life for Lithuanian Americans.

The Korean Presbyterian Church of Metro Detroit is located at 27075 West Nine Mile Road. Built in 1977 and originally known as the Korean Community Church, this church is the first church built for a Korean congregation in the United States. The church conducts services in Korean and dedicated a youth center in 2008. (Author's collection.)

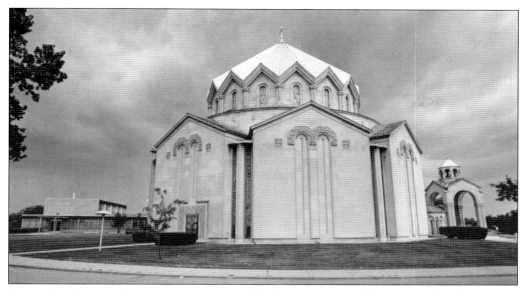

Ground was broken for the main sanctuary of St. John Armenian Church in 1964. Designed by architect Suren Pilafian of Detroit, the gold dome is unmistakable on the Southfield skyline. The entire church complex was built at a cost of $2.5 million dollars with major donations from Alex Manoogian and Edward Mardigian. A center of Armenian life in metro Detroit, the church hosts children and youth programming, retreats, and choirs. (Photograph by the *Detroit Free Press* staff, author's collection.)

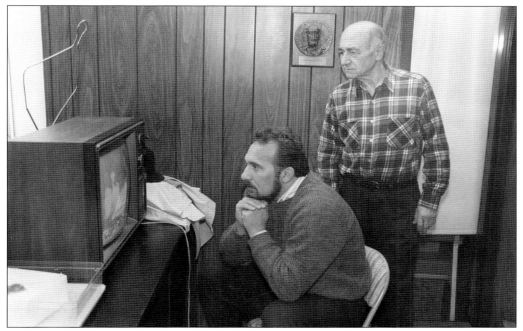

In St. John Armenian Church, Armenian Americans Jivayer Hovsepian (seated) and Harry Chrovian watch news coverage of the Spitak earthquake which inflicted great damage in northern Armenia in December of 1988. (Photograph by *Detroit News* staff, courtesy of Walter P. Reuther Library, Archives of Labor and Urban Affairs, Wayne State University.)

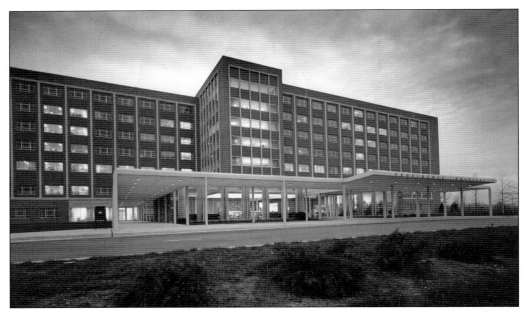

Providence Hospital has its origins in Detroit, founded as the House of Providence by the Daughters of Charity in 1869. The house sheltered unwed mothers and ran programs for these women and their children. The House of Providence moved to Southfield in 1965. The building was designed by Giffels and Rossetti.

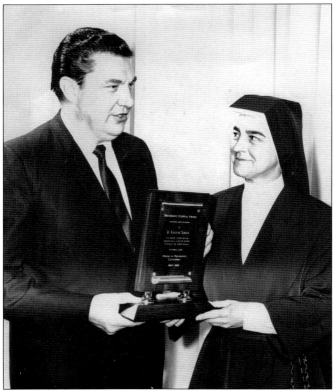

Providence Hospital celebrated 100 years of service in 1969. As part of the centennial celebrations, Providence Hospital head administrator Sr. Gertrude Bastnagel presents an award to D. Eugene Sibery for 23 years of service in the public health field. Sibery was the executive vice president of the National Blue Cross Association and the former director of the Greater Detroit Hospital Council.

Seven
CIVIC DEVELOPMENT

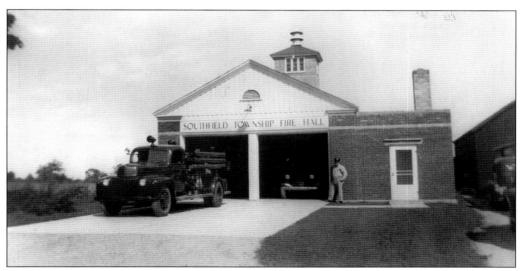

The first Southfield fire hall was built in 1942, the same year the township established its Fire Department. The rural township was served by a firefighting force of just two full-time men while the Oakland County Sheriff's Department provided police protection since the township had no police force. In 1949, the fire department moved into a more centrally located fire hall at the corner of Ten Mile and Evergreen Roads.

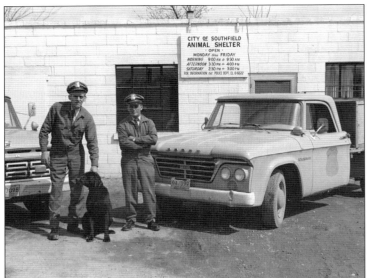

The City of Southfield's animal shelter is shown here in this undated photograph. Stray dogs became a concern as more families moved into the city. As Southfield grew and additional city services were needed, new departments were housed in spaces that were available.

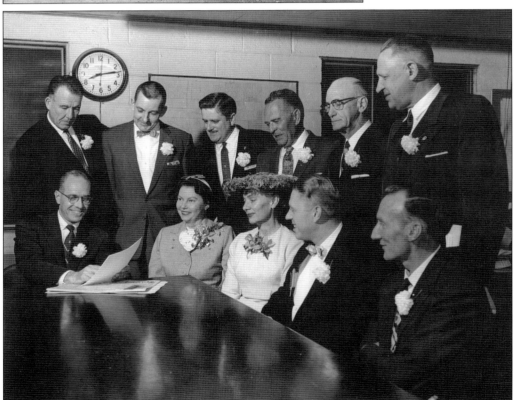

This photograph shows the first meeting of the Southfield City Council in April 1958. Southfield had an arduous path on its way to becoming a city, and pressure built as several portions of Southfield Township were carved into adjacent communities in the 1950s. Franklin was incorporated as a village in 1953, and Lathrup Village became a city that same year. Bingham Farms followed suit in 1955.

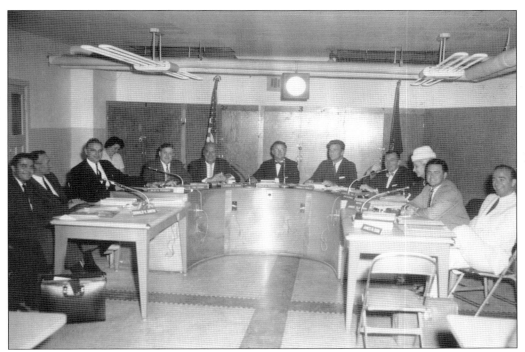

After two unsuccessful attempts, Southfield became a city in 1958. As seen here in 1962, early city council meetings were housed in the basement of Southfield School No. 10. From left to right are city manager Donald Smith, city clerk Pat Flannery, Alex Perinoff, Garnetta Haeger, Hugh Dohany, Clarence Durbin, Phil Peterson, Tom Rowley, Dane Edwards, Jean McDonnell, Mayor James Clarkson, and city attorney James Ginn.

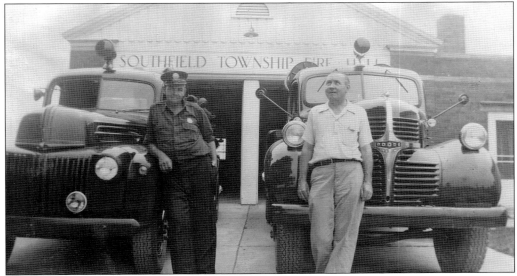

Firefighters Clifford Hughes (left) and Nelson Hughes (right) stand by Southfield's two fire trucks in this 1940s photograph. When the fire department was in its infancy, it bought a used 1,000-gallon tanker and a new 200-gallon fire truck. The old fire hall on Berg Road was used by the water department until the 1970s. It is now a part of the Burgh Historical Park.

81

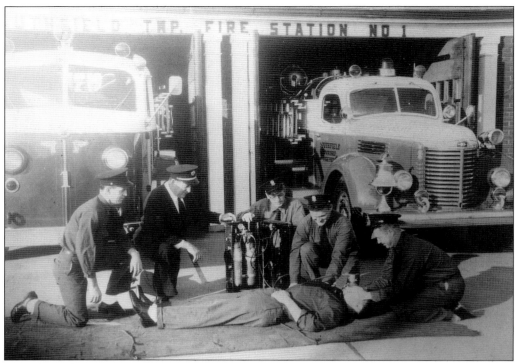

Firefighters showcase their life support skills outside of Station No. 1 in this undated photograph. Southfield's fire department has long embraced advanced training, becoming the first department in the nation to establish a life support unit in 1972. It became a model for similar units nationwide.

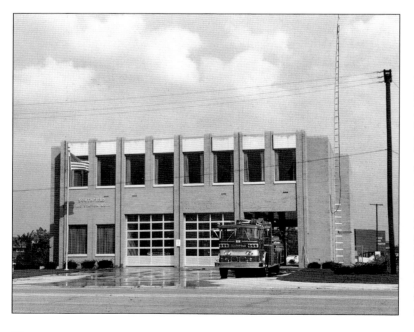

In 1960, the Southfield Fire Department entered into a contract to protect Lathrup Village and that arrangement continues today. Located at 18400 West Nine Mile Road, the Southfield Fire Station No. 1 was built in 1967. Six new firefighters were hired that same year.

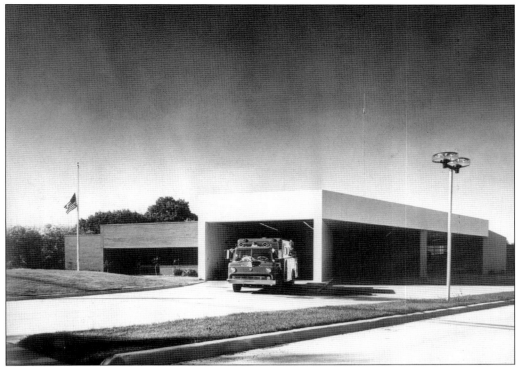

In April 1977, the fire station headquarters opened. Located at 24477 Lahser Road, it is known as Station No. 5. In 1979, the Arson Investigation Team was founded. Two years later in 1979, the fire department administration unit moved from Station No. 5 to the public safety building. Today, Southfield is Oakland County's busiest fire department, responding to an average of 42 calls per day.

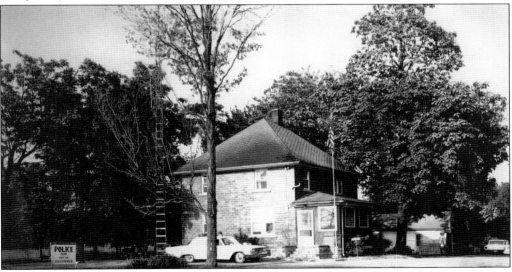

The Southfield Police Department began in 1953 and the original police chief Phillip La Vigne worked out of the old township hall. From 1958 to 1964, the police force worked from a house on Evergreen Road south of Mary Thompson's farmhouse, pictured here in 1964.

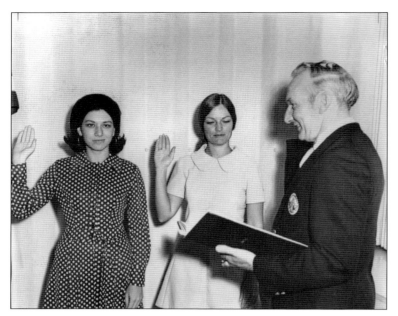

Several new policewomen are sworn in in this undated photograph. Based on personnel photographs of the Southfield Police, there were no women on the force in 1960, but by 1968, there were several. After employment laws were changed in the early 1970s, police departments across the United States began hiring more women.

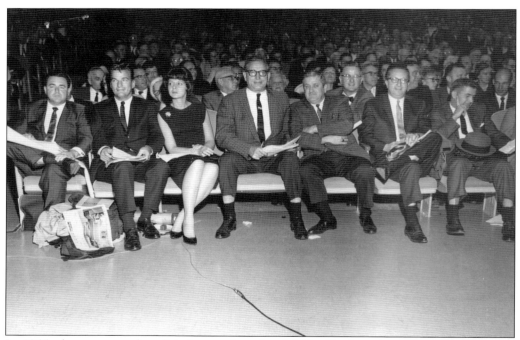

In 1965, there was much political turmoil as Southfield officials and residents grappled with where the new Interstate 969 freeway would be routed. Residents of Southfield pack Ferndale High School to discuss the freeway and its implications in this 1965 photograph. All communities located along the freeway's proposed route tried to balance competing viewpoints between their residents, elected leaders, and the Highway Commission.

The staff of the city treasurer's office are pictured above in 1968. Below, city officials unveil a painting of Clara Lane in 1967. Lane was a longtime resident of Southfield who began working in the township's treasury department in 1941. In 1943, she was appointed treasurer to fill a vacancy and was later elected to the same position by voters in 1946. After Southfield became a city, she served as the treasurer of the City of Southfield from 1958 until her death. After her death in 1966, a tree was planted near the library, and a portrait was dedicated in her honor.

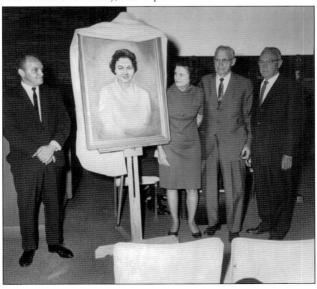

85

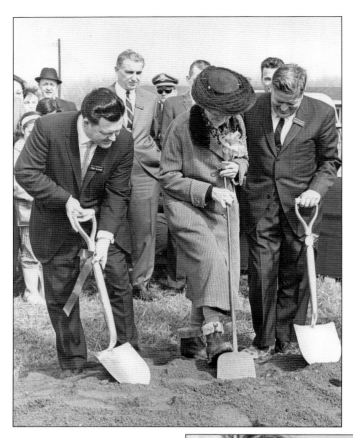

Ground was broken for the new Southfield Civic Center in 1963. After selling part of her farm to the city at a discounted price, Mary Thompson participates in the ground breaking flanked by Mayor James Clarkson on the left and Councilman Hugh Dohany on the right.

Councilman Hugh Dohany pins a corsage onto Mary Thompson's lapel during the ground breaking for the new civic center. The $2 million-dollar civic center project was completed in 1964. Southfield continued developing its civic campus in the years that followed. In 1970, the civic center arena opened. The indoor ice-skating rink and swimming pool were popular with residents who flocked to the facility for communal recreational purposes.

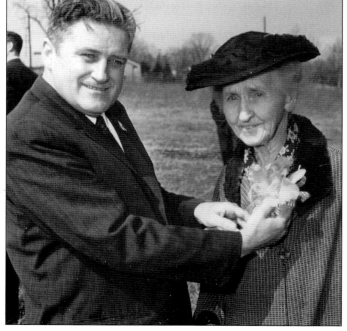

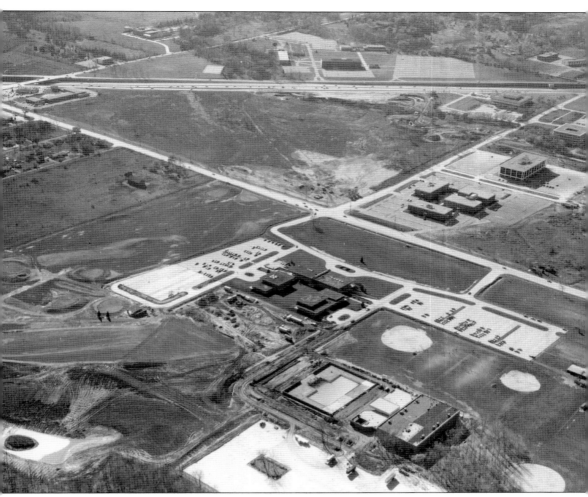

Today, set on 186 acres, the Southfield Civic Center is an expansive campus that includes the city hall, a library, a courthouse, and recreation facilities including a sports arena, swimming pool, tennis courts, and a playlot. The first buildings constructed (including the city hall) are excellent examples of modern design. The firm Crain & Gorwic was retained to design the campus while the buildings (city hall, the parks and recreation building, and the original Southfield Library) were designed by Ferndale firm Pirscher & Jarratt. This firm was formed by Carl W. Pirscher and William R. Jarratt in the early 1960s as a successor to Carl's eponymously named firm Carl W. Pirscher & Associates. Pirscher & Jarratt also designed the South Oakland YWCA Activities Building in Clawson, Miles Peele Hall at Adrian College, the Herrick Public Library in Holland, the Maple Office Center in Birmingham, and Christ Lutheran Church in Redford, among others.

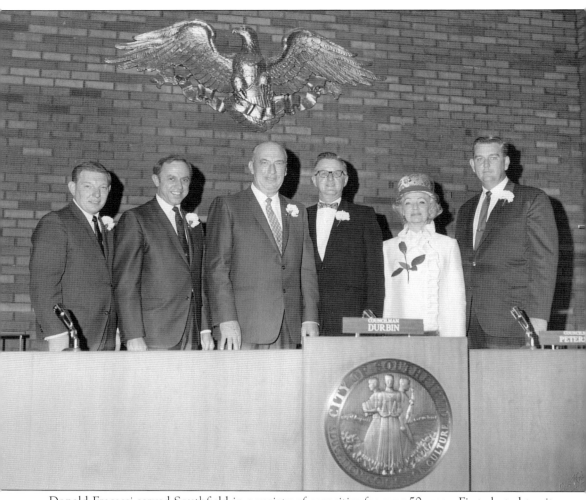

Donald Fracassi served Southfield in a variety of capacities for over 50 years. First elected to city council in 1967, Fracassi served as acting mayor from 1969 to 1972 and was then elected mayor from 1973 to 2001. He then served on the city council again in 2003 and became acting mayor in 2015. His public service to Southfield cannot be overstated as he ushered Southfield through profound changes during his 50 years in office. Fracassi was instrumental in launching one of the first 911 Emergency Systems in the country in 1972, establishing the Burgh Historical Park in 1976, starting curbside recycling in Southfield, and many other notable accomplishments. In 2020, Southfield's civic center was renamed the Donald F. Fracassi Municipal Campus to honor the long-serving mayor. Fracassi passed away in 2023. From left to right are Don Fracassi, Steve Hurite, Clarence Durbin, Phil Peterson, Jean McDonnell, and Neil Wallace.

Members of the Southfield government are shown inspecting the development of the Evergreen Hills Golf Course in 1972. Located just south of the Southfield Civic Center, the Evergreen Hills Golf Course was designed by W. Bruce Matthews III and opened in 1972. Don Fracassi is on the right.

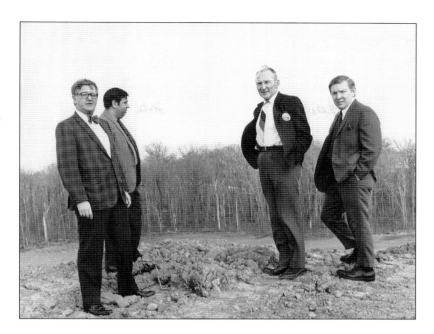

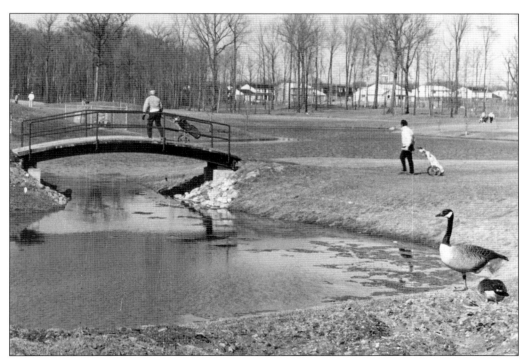

Today, Southfield has two public golf facilities (a golf course and a driving range) along with the private Plum Hollow Country Club. In the past, Southfield had the Lancaster Golf Course, which was located on the northeast corner of Twelve Mile and Telegraph Roads, and the River Bank Golf Club at Northwestern Highway and Eleven Mile.

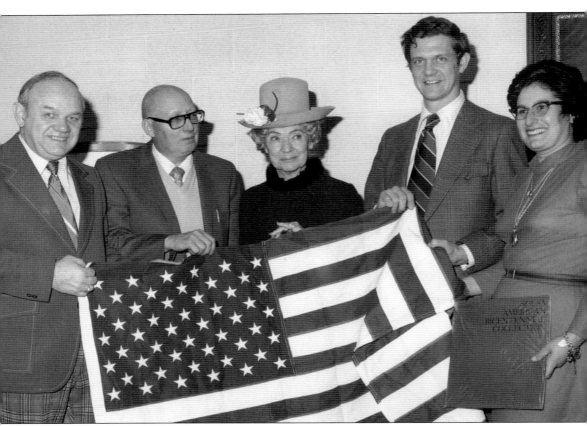

Like many towns across America, the City of Southfield celebrated America's Bicentennial with many events aimed at celebrating history. It was the bicentennial that brought a concerted effort to save what remained of Southfield's historic town center on Civic Center Drive. Several groups were involved in these historical and preservation efforts, including the City of Southfield, the Southfield Historical Society, the volunteer firefighters (who restored the old fire hall on Berg Road), the arts council, and the parks and recreation department, among others. Because of the Bicentennial and advocacy by Southfield officials and residents, the Simmons House, the old town hall, and the Methodist church were moved to the northeast corner of Berg Road and Civic Center Drive to create the Burgh Historical Park. Southfield Historian Fred Leonhard is pictured second from left, Jean McDonnell is beside him, and Vicki Goldbaum is at the far right in 1975.

Vicki Goldbaum was a member of Southfield's city council for many years and an ardent advocate for preserving Southfield's disappearing architectural legacy. She was also instrumental in urging more women to serve in city government via her service on the National League of Cities' Women in Municipal Government group, which she chaired. She authored three books on the history of Southfield and was an accomplished artist.

The restored Simmons House is now a part of the Burgh Historical Park, seen here in a recent photograph. The Simmons House was used for years by the City of Southfield Human Resources Department, and it is now used as a satellite office by Southfield's US congresswoman.

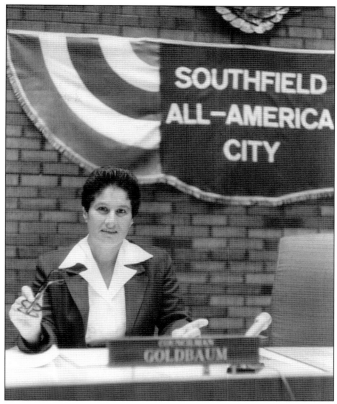

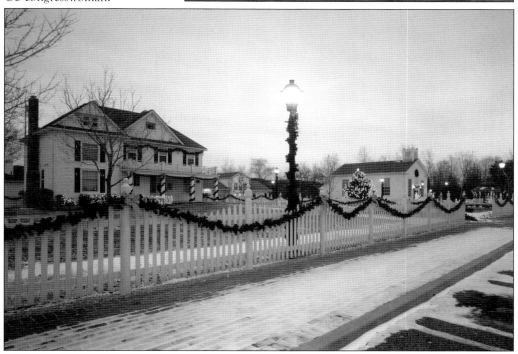

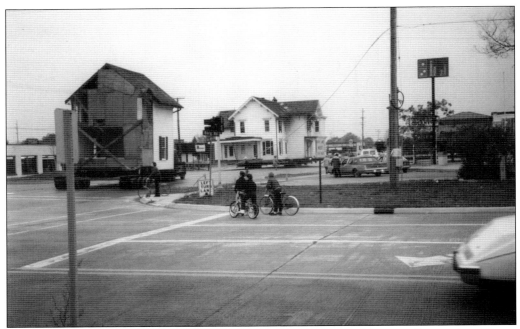

The Parks house was built by Mary Thompson's grandfather and historically stood at Eleven Mile and Evergreen. When the historic house—an excellent example of Folk Victorian–style architecture—was threatened with demolition because of the impending Interstate 696 freeway, the City of Southfield bought the building knowing it would need to be moved. Thus, in 1985, the house was cut into two pieces and moved to the Burgh Historical Park. Crowds gather as the house is carefully transported down the street.

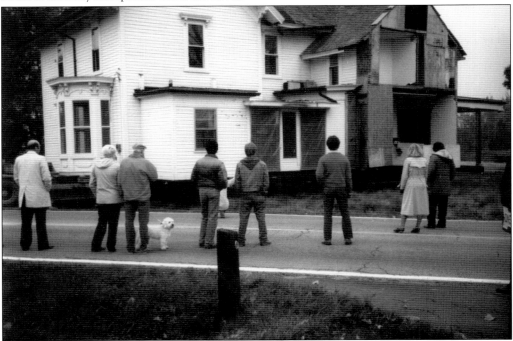

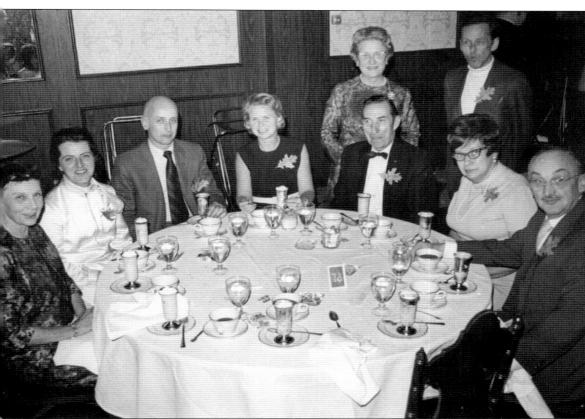

Friends of the Southfield Public Library gathered in 1969 for the City of Southfield Commission Dinner at the Raleigh House. Seated from left to right are Mrs. Neil McGregor, Mrs. Rod Staperfene, Mr. and Mrs. Larry Spademan, Mr. and Mrs. John Grimes, and Dr. Oliver Marcotte (the persons standing are unidentified). The Friends have been a continual support to the Southfield community, integral to the establishment and advancement of Southfield's library. Hosting events for the community and raising money for library needs and functions, the Friends of the Southfield Library are still active. Today, their activities include organizing book sales at the "Book Shelf" store on the main floor; hosting jazz and other music programs, lecture series, and presentations; and collecting donations to use for items and services intended to improve the library. The Friends of the Southfield Public Library are still highly active today.

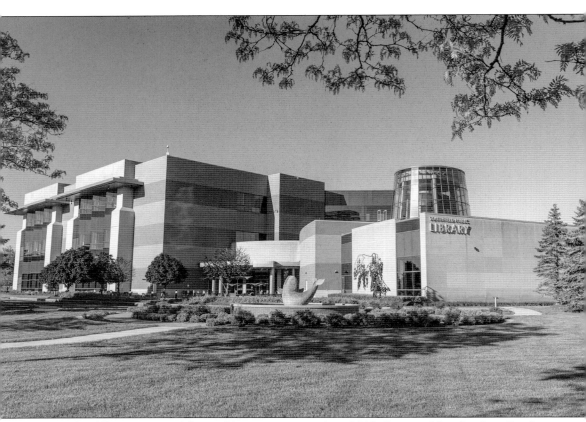

Southfield's new state-of-the-art library was opened in 2003. Designed by the firm Dewberry, the 120,000-square-foot facility has state-of-the-art facilities including an auditorium, a themed children's castle with Slumber the Sleeping Dragon, fireplaces, and a large 200-seat meeting room. The building received numerous awards for its innovative design. Library services have come a long way in Southfield. The first dedicated city library building was the Brooks School which was converted to use as a library in 1960 after classes were moved out of the building. In 1964, the library moved to the newly built facility in the civic center and this facility was expanded in 1969 to include a dedicated children's room. Approximately 45,000 books were circulated at that time. Today, the Southfield Public Library holds a collection of over 280,000 volumes and continues to incorporate new services to meet the changing needs of Southfield's residents. (Author's collection.)

Eight
LIFE IN SOUTHFIELD

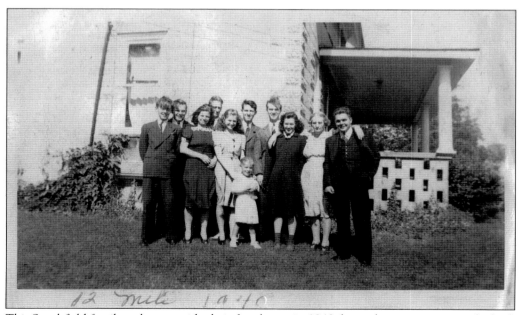

This Southfield family gathers outside their farmhouse in 1940, located per notations on the back of the photograph, at 20220 West Twelve Mile Road. It is believed this may be the Gudenburr family, as they are recorded as living at 20220 West Twelve Mile Road in the 1940 census.

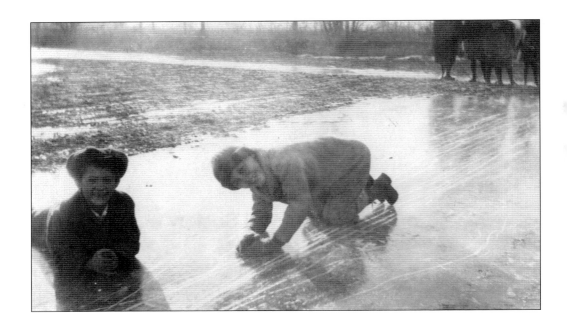

Two early (undated) photographs show unidentified children playing in Southfield. Children in Southfield got creative in order to keep themselves entertained. These children play on the ice and have started a baseball game with minimal equipment—notice the piece of lumber being used as a bat.

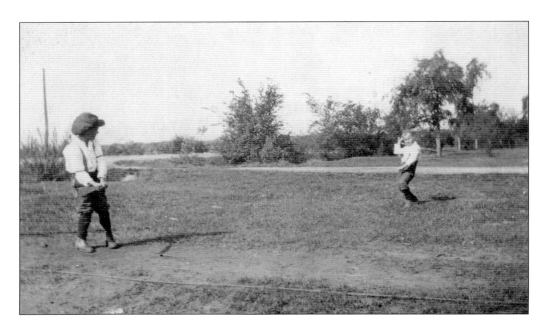

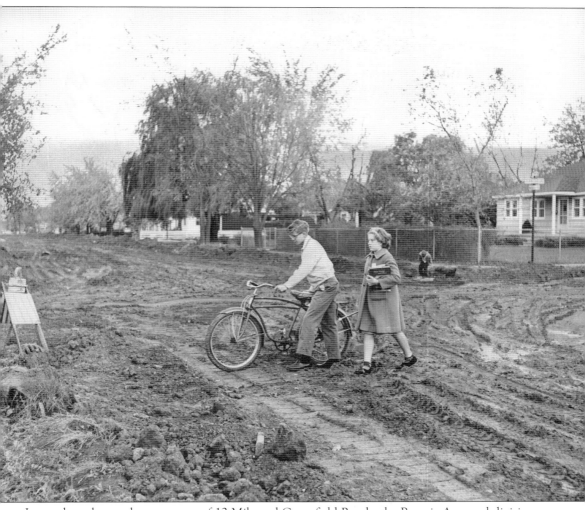

Located on the southwest corner of 12 Mile and Greenfield Roads, the Bonnie Acres subdivision primarily consists of small ranch- and Minimal Traditional–style houses built in the 1920s through the 1950s. Advertisements for lots in Bonnie Acres first appeared in 1922, and by 1923 the *Detroit Free Press* reported that 23 homes had been constructed. Newspaper advertisements for houses and lots for sale in this neighborhood were numerous in the early 1920s. The corporation Bonnie Acres, Inc. was organized in 1940. An unidentified boy and girl walk across Marshall Street at the intersection of San Rosa Avenue in the Bonnie Acres subdivision in this undated photograph. Public works in Bonnie Acres (note the construction sign at the left of the photograph) caused turmoil for residents, and the water supply to this neighborhood was a particular issue. (Photograph by *Detroit News* staff, author's collection.)

Southfield has had several prominent newspaperwomen—the founder of the *Southfield Newsette* and the founders of the *Four Corners Press* were all women. Frances Borowski, pictured here, founded the *Southfield Newsette* in the 1930s. It was originally a mimeographed newsletter with a hand-drawn masthead that was distributed amongst members of the Southfield Women's Club. The *Southfield Newsette* carried news articles on the district schools, church news, residents hosting parties or traveling for vacation, and other small-town events. During World War II, the *Southfield Newsette* also published letters from Southfield servicemen. When Frances died in 1947 from complications in childbirth the paper was bought by Thomas Thorburn in 1948. That same year, Thorburn revised the *Newsette* and renamed it the *Southfield News*. In 1950, the rival *Four Corners Press* purchased the *Southfield News* from Thomas Thorburn, and the paper became known as the *Four Corners Press/Southfield News*.

Southfield experienced a housing boom in the 1950s and 1960s. The houses being built contained modern kitchens fitted with new conveniences like dishwashers, built-in ovens, and electric stovetops. This kitchen was advertised by the Peerless Kitchens cabinet company and was located in the Evergreen Trail Subdivision, which was just north of Eleven Mile Road and west of Evergreen Road. Developed by Living Modes, Inc., a 1961 advertisement for the Evergreen Trail Subdivision proclaimed the sub had "trees like you've never seen before" and boasted that new owners would live in a "wooded wonderland." Living Modes, Inc. also built houses in the Burton Hollow subdivision in Livonia. Houses in the Evergreen Trail subdivision were priced between $21,000 and $25,000. The new houses were predominately Ranch and Colonial Revival styles and included four models, the Parliament, the Yorkshire, the Oxford, and the Sherwood. Later, developer Suburban Living, Inc. also constructed new homes in the neighborhood. (Author's collection.)

Unidentified children participate in the A.J. "Bud" Williams-sponsored kite flying contest in Southfield at Southfield High School. Bud Williams was a native of Sarnia, Ontario, who founded the successful Williams Services, Inc. company in Detroit. Williams Services, Inc. provided office and staffing services.

The Fourth of July parade on July 2, 1976, in Southfield is shown in these two photographs. As America's 200th birthday loomed, Congress created the American Revolution Bicentennial Administration, which helped and encouraged local communities in their planning. Large events were planned in cities like New York, Washington, DC, and Philadelphia as well as smaller communities that hosted parades, created historic districts, and staged plays and reenactments of historical events.

Gordie Howe lived in Lathrup Village (directly adjacent to Southfield) and participated in this parade on the Fourth of July during an unknown year. Called "Mr. Hockey," Gordie Howe moved to Lathrup Village around 1960 and lived at 28780 Sunset Boulevard. The Howe family later used this house as collateral to build a children's hockey rink in St. Clair Shores. Called the Gordie Howe Hockeyland Ice Arena, it was located at 33101 Harper Avenue. Opened in 1964, this arena fielded multiple divisions (based on age), hosted games, and had an intensive hockey training school. The rink sat 700 spectators and measured 85 by 185 feet. It could be rented by the hour for private lessons or for groups.

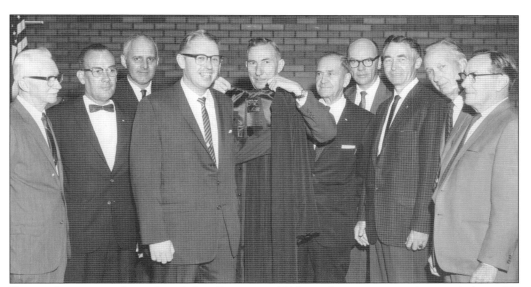

Kiwanis International was founded in Detroit in 1915 as a business networking and charitable organization. The Kiwanis Club raised money for charitable causes by holding charity events and putting on shows. The Kiwanis of Southfield presented "Frolics" in the 1950s in the Southfield High School auditorium. Pictured here, members of the Kiwanis Club gather to honor one of their members in 1964.

A Southfield-themed float rolls down the street in this mid-century parade. This float appears to be participating in a parade held in Detroit or a neighboring community as the housing stock differs from that which is typically found in Southfield.

103

Organized dancing events and card games were popular activities in the 1940s–1960s. Card games in particular were popular for entertaining friends at home, and games like bridge, canasta, euchre, and pinochle were all popular during the era when these photographs were taken. Many houses in Southfield would have been equipped with a folding card table, as bridge parties were common.

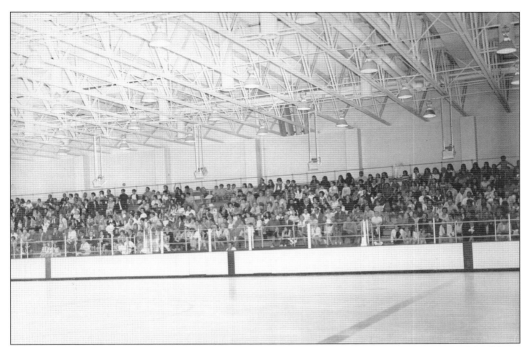

The Southfield Civic Center has a large recreational facility that includes a recreational building, the indoor regulation-size hockey rink shown here, and an outdoor Olympic-sized swimming pool, tennis courts, and other features. Today, the swimming pool is closed but Southfield residents can use the Oak Park swimming pool on specific days.

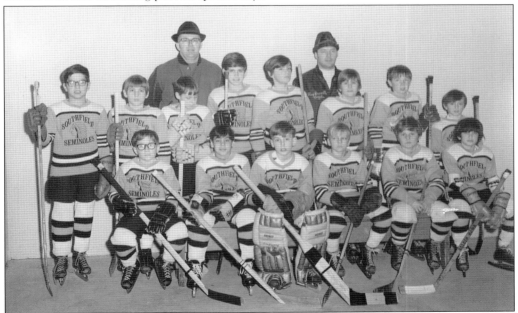

In the 1970s Southfield had a large recreational hockey program—the Southfield Hockey Club—which included divisions based on age. These teams were part of the National Midget Hockey Tournament. This is the Southfield Seminoles team in 1970.

105

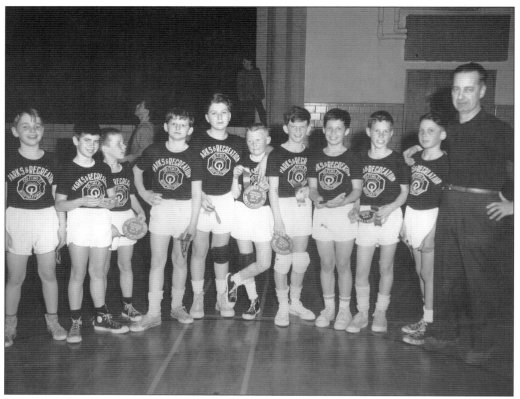

Today, Southfield has a robust Parks and Recreational program and this legacy traces back to the 1950s and 1960s when recreational activities were organized by the Parks and Recreation Department. Pictured above is the 1961–1962 Class E boys basketball championship team sponsored by the Southfield Optimist Club. Below are staff/participants from the Southfield Parks and Recreational Department in an undated photograph.

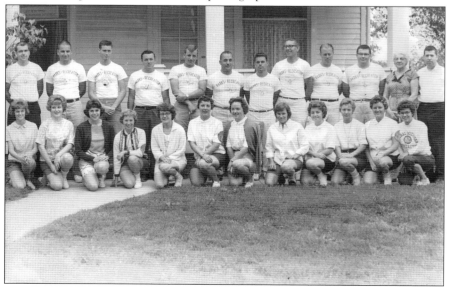

Plum Hollow Country Club is centered around a top-rated 18-hole golf course designed by Harry Colt and Charles Hugh Alison. The land used to be owned by the Kirchoff family who had a dairy farm on the property. Wild plums grew profusely in the bottomlands and the area was known as Plum Bottoms. The Plum Hollow Golf Club was organized in 1921 by a dozen Detroit men who began soliciting their friends and acquaintances for membership. The nascent organization paid $95,000 for the 157-acre Kirchoff farm that same year. Two hundred members were eventually assembled, and in lieu of other options, those original members gathered in a barn on the old farm property. The first clubhouse was built in 1923 and was reportedly constructed of lumber salvaged from old sheds on the grounds of the Cadillac Motor Car Company factory. The Rouge River cuts through the property and the resulting undulations, ravines, hollows, and river sand deposits make for an ideal golf-playing topography. The club suffered several fires—one in 1944 and two in 1959, the latter of which completely destroyed the clubhouse. Designed by O'Dell, Hewlett and Luckenbach, this architectural model shows the proposed design for the new clubhouse in about 1960.

Southfield has a long history of active neighborhood associations in the city's various subdivisions. Founded in 1948, the Oakland Village Civic Association is one such group and they were formed primarily to help monitor building restrictions and zoning changes that might affect the neighborhood. The Oakland Village Association held organized square dances and published newsletters that went out to all members of the group with news on traffic issues, zoning changes, upcoming elections, assessor's office updates, and other Southfield news. Another organization, the Magnolia Neighborhood Association helped campaign for school consolidation and later, in the 1960s, banded together to thwart unscrupulous real estate agents engaged in blockbusting as the first Black families moved to the subdivision. In this picture, the Oakland Village Civic Association gathers around an old-fashioned cracker barrel during a meeting. From left to right are Mr. and Mrs. Paul McElwin of Samoset Trail, Mr. and Mrs. John Bennett of Rougecrest Drive, Mr. and Mrs. Roy P. Jensen, of Ingleside Drive, Lee Decheim of Ingleside Drive, and Mr. and Mrs. William Rogers of Samoset Trail.

The City of Southfield held a large fair on the grounds of the Southfield High School in 1960. A man with children speaks to a woman from the *Southfield Sun* who had a booth to explain the process used in producing their weekly newspaper. Southfield has had several newspapers including the *Southfield Sun*, the aforementioned *Southfield Newsette*, the *Four Corners Press*, and the *Southfield Record*, among others. In 1949, the *Four Corners Press* was founded by Betty Lewis and Marion White in the northern part of Southfield Township. In 1959 the *Four Corners Press/Southfield News* was renamed the *Southfield News*. In 1970, the *Southfield News* was rechristened the *Southfield News and Observer* when it merged with the *Observer* newspaper chain. The year 1970 also saw the establishment of the *Southfield Eccentric* newspaper. Later, the *Southfield News and Observer* merged with the *Southfield Eccentric* to become the *Southfield Observer-Eccentric* in 1974.

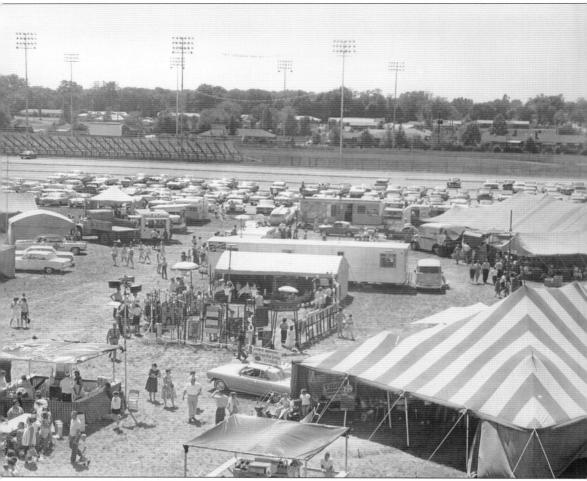

Held the first weekend in July, the City of Southfield held a large fair on the grounds of Southfield High School. Called the Southfield Fair, this photograph shows the fair in 1960, but it ran for many years through the 1960s. The fair was intended to raise money for Southfield schools and included a midway, carnival rides, games, and raffle contests. In 1966, the local band the Shy Guys and the Chosen Few played the Southfield Fair. In 1967, Bob Seger and the Last Heard, the Rationals, and the Mama Cats all played the fair. The Detroit music scene was tight-knit in those days and there was a wealth of talent playing gigs around the metro area. A year after playing at the Southfield Fair, Bob Seger and the Last Heard signed with Capitol Records, which changed the band name to the Bob Seger System. Seger was friends with Royal Oak native and musician Glenn Frey, who performed background vocals on Seger's first national hit "Ramblin' Gamblin' Man." Frey later formed the Eagles with fellow musician Don Henley.

In 1972, the Southfield Chamber of Commerce in partnership with *Southfield Sun* newspaper gave awards to companies and other entities who kept up their properties. Here, the Air-Matic Products Company accepts an award for "Most Beautiful Building."

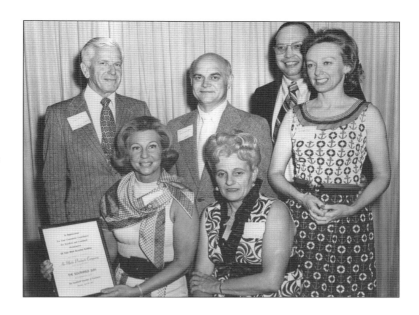

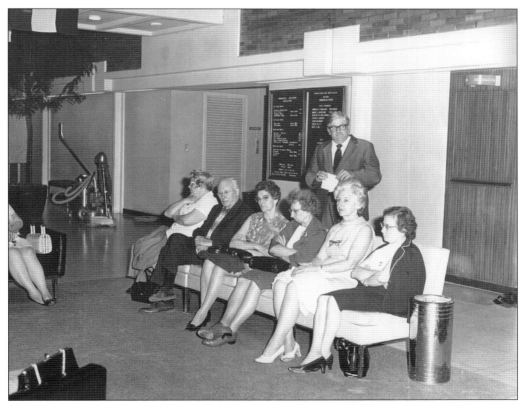

Members of the public and city officials gather at the Southfield Municipal Building. This photograph is undated but was taken during the term of Southfield mayor Norman Feder, which spanned from 1969 to 1972.

Dr. Oliver J. Marcotte was a physician who lived in Southfield for many years. A respected practitioner and the official physician for the City of Southfield, Dr. Marcotte's office at 25000 Ten Mile Road is shown here in December 1958–the office opened in 1959.

The Navy Reserve Center located at 26400 West Eleven Mile Road is pictured here in 1973. Navy Reserve Centers are used to handle administrative functions and to host training for Reservists. The Navy Reserve Center is set amongst many other industrial buildings north of Holy Sepulchre Cemetery.

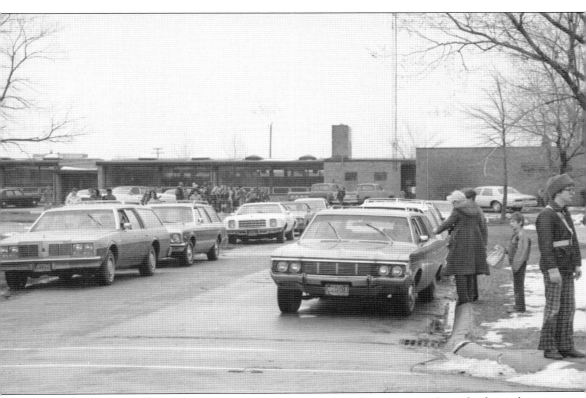

From 1976 to 1977, Oakland County residents were terrorized by a string of unsolved murders. This series of events is known as the Oakland County Child Killings, and many Southfield residents retain memories of this terrifying year as one of the victims was found in Southfield. Four murder victims are directly linked to the Oakland County Child Killer with several more suspected. Newspapers covered the story extensively and a county-wide manhunt ensued when the fourth victim went missing. A blue AMC Gremlin was believed to be connected to the disappearances, so police then questioned every AMC Gremlin owner in the county. There was a task force set up to handle the case and more than 18,000 tips were investigated. Despite these efforts, and even with several suspects, no one was ever charged in connection with the murders. Shown here, frightened parents pick up their children from St. Bede's school in Southfield in 1977 during the height of the Oakland County child murders.

Black families faced enormous hurdles to buy property and accumulate wealth via home equity. Discriminatory housing policies, redlining, unscrupulous real estate agents using blockbusting and steering tactics to perpetuate segregation, and discriminatory bank lending practices all suppressed Black homeownership. Despite these odds, Black families began moving into Southfield by the late 1960s and early 1970s. In 1977, Black residents comprised about 5% of the population in Southfield. Today Southfield is about 65 percent Black. From left to right, James Allen Jr., his daughter Lolita Allen, and his wife Agnes Allen are shown here in front of their Southfield home in 1980. James Allen Jr. was born in Detroit's Black Bottom neighborhood and progressively moved his family up the housing ladder, seeking better neighborhoods for his family. The Allens bought their home in Southfield's Northland Gardens neighborhood in 1979 after moving to Southfield from the northside of Detroit. (Photograph by *Detroit Free Press* staff, Author's collection.)

The McDonnell Towers was a senior housing high-rise completed in 1975. At the dedication of the senior housing complex, Mayor Don Fracassi welcomes the crowd while standing at the podium. The first female city councilwoman in Southfield, Jean McDonnell, is seated with a hat on. Jean worked tirelessly to bring the McDonnell Towers project to fruition believing firmly that senior housing should be a priority for her community. Despite some initial hesitation on the part of the public, the towers were completed in 1975 due to McDonnell's tireless campaign for support. The housing complex was named in McDonnell's honor. Gov. William Milliken is seated second from left.

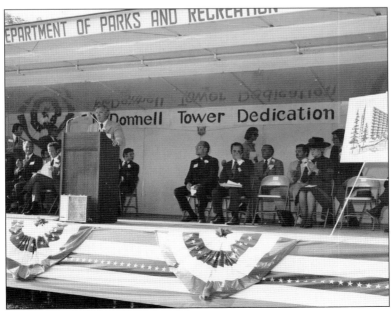

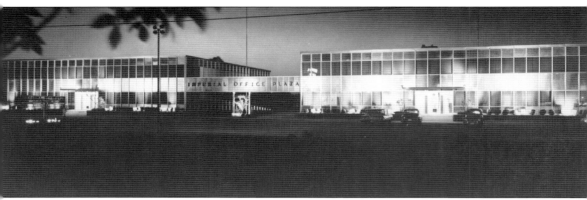

The Imperial Office Plaza was located at 17220 West Eight Mile Road and built by Harold E. Soble of 22152 Rutland. The building featured terrazzo corridors, light fixtures recessed into the acoustical tile ceiling, and marbleized vinyl flooring in the offices. Soble also built the office building next door which was described as a "gold and glass" structure and formally known as the Southfield Plaza building. Both of these buildings were modern-style buildings typical of Southfield's mid-size commercial architecture built in the 1960s. The Southfield Plaza building, located at 17000 West Eight Mile, was designed by Samuel P. Havis of Havis & Glovinsky Associates and had two sections that were linked by an arched, barrel-vaulted connector wing enclosed with large expanses of plate glass. The Southfield Plaza building cost $2.54 million and had 400 parking spaces. The Southfield Plaza building was demolished between 1997 and 2000 while the Imperial Office Plaza was demolished between 2000 and 2002.

Nine
ARCHITECTURAL GEMS

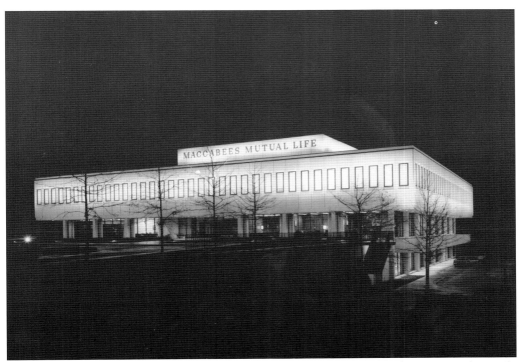

As a collective whole, Southfield contains some of the best examples of mid-century-modern-style architecture in the state. The Maccabees Mutual Life Insurance Company had its origins in a fraternal organization known as the Knights of the Maccabees. The Maccabees provided low-cost life insurance to its members and this function grew over time as its fraternal activities declined. Completed in 1962, it was designed by Harley, Ellington, Cowin & Stirton.

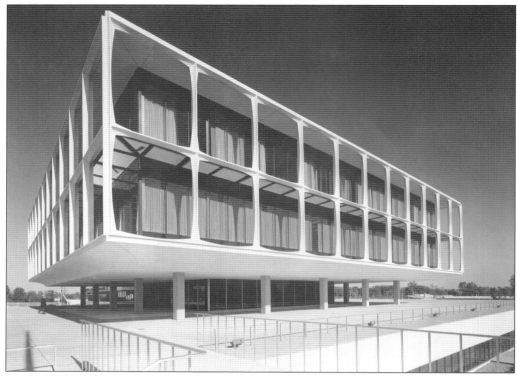

The Federal Mogul Staff Building, pictured here, was designed by Louis A. Rossetti while working at the firm Giffels & Rossetti. Rossetti designed numerous architecturally significant buildings in Michigan including Huntington Place (the former Cobo Center). Construction of this 148,000-square-foot complex began in 1965 and, upon completion in 1966, the building featured a glass lobby and a distinct pre-formed, pre-stressed concrete grid-like frame. This outstanding modern-style building has lost its architectural significance as it was stripped of its distinctive frame and completely altered in 2020 by new owner Marelli North America, Inc.

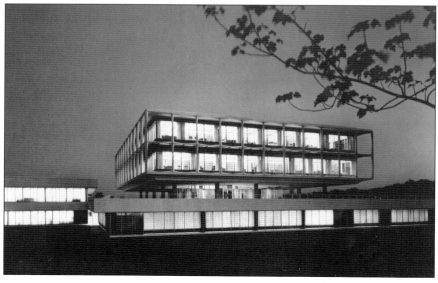

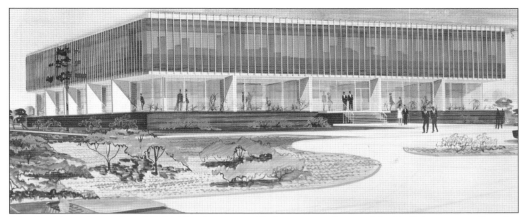

This building, located at 26201 Northwestern Highway, was designed by P-F Associates, Inc. for the E.F. MacDonald Travel company and was completed in 1965. P-F Associates also designed the College Park condominiums in Ypsilanti. Later, the Eaton Corporation took over the E.F. MacDonald building.

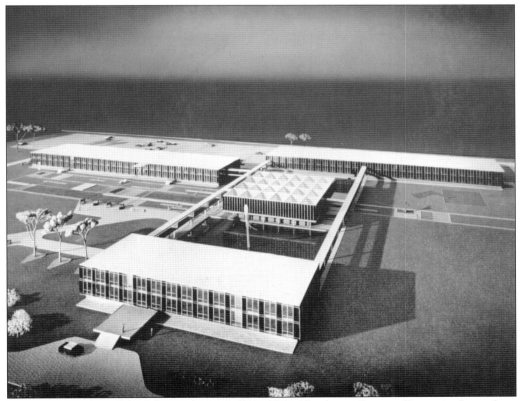

An architectural model of the Michigan Bell Building Northwest Service Center is shown here in 1960. As telephone usage soared in the 1950s and 1960s, Michigan Bell acquired property at 23500 Northwestern Highway to build this campus.

These ranch-, modern-, and contemporary-style houses are located in the Northland Gardens subdivision off Eight Mile Road. Plated in 1956 by the Hudson-Webber Realty Company, this subdivision was built as the residential component of the much larger Northland Center development, which included the Northland Center shopping mall as well as various other commercial and office buildings. This neighborhood is highly cohesive with relatively few alterations or modern infill buildings. Nominated to the National Register of Historic Places in 2020, this subdivision is important as a collective example of mid-century architectural design. Legendary musician Smokey Robinson lived in the home pictured below from 1970 to 1973. Many other Motown artists lived in Northland Gardens as well. (Both, author's collection.)

The Washington Heights neighborhood was developed by Lee Baker in the late 1920s when Baker built the McKinley School on George Washington Avenue to attract residents to the subdivision. The Great Depression put a damper on the development but, by the 1950s, building picked back up. Although there are a few period revival-style houses in the neighborhood that pre-date World War II, most of the houses in the neighborhood are mid-century ranch-, contemporary-, and modern-style homes, many of which appear to be custom-built, architect-designed residences. Both of these houses feature wide front gables, which are typical of the contemporary style. (Both, author's collection.)

121

This architectural rendering shows Stouffer's Northland Inn in 1961, which was a six-story restaurant and hotel with 192 guest rooms. At the top of the building, there was a glass-enclosed restaurant called the Coach and Four. The Coach and Four was decorated in the "Old English" style with dark wood wainscoting and oak beams.

This 1961 rendering shows the design of the two towers that made up the proposed Northland Towers development. The buildings were designed by H.L. Vokes Co., which also provided the engineers and general contractors for the complex. The first tower was constructed in 1960–1961, and it was reported that the second tower would be constructed when there was enough demand for office space.

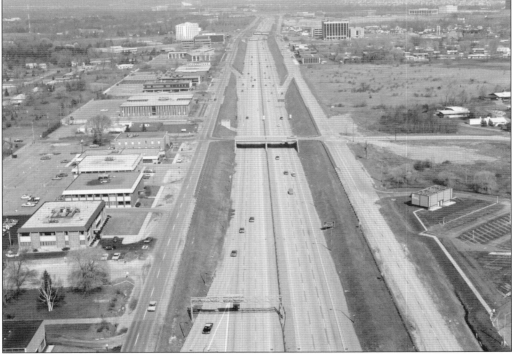

All along the Lodge Freeway service drive, mid-rise mid-century-modern-style office buildings dot the landscape in this 1974 photograph. There were so many significant architects building new office structures for companies leaving Detroit and these smaller buildings gain architectural significance based upon the collection as a whole. On the left side of the Lodge Freeway, the H-shaped building in the mid-ground is the old Metro Center Building (now the Kevdaco Center). In the background on the left side, the splayed three-wing building is the old IBM building (now known as the Crescent Building), while the white, taller structure in the background on the left is the Heritage Plaza building (now known as the Centrum Office Center/Mike Morse law firm). On the right side of the lodge, the Colonnade Building (now the offices of Joumana Kayrouz) is visible in the upper-right background. Note the outstanding mid-century-modern-style residence on the right of the Lodge Freeway in the middle ground—this house on Lafayette Circle is pictured on page 121.

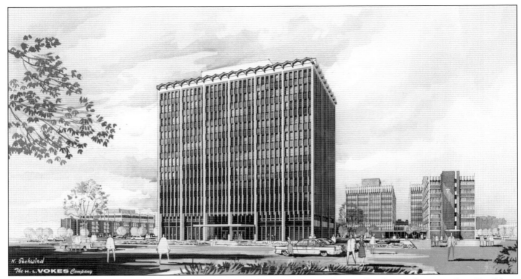

The Midwest Housing Center was completed in 1967 and was built to house the Builders Association of Metropolitan Detroit as well as building material suppliers and construction services companies. The general contractor was H.L. Vokes Company out of Cleveland.

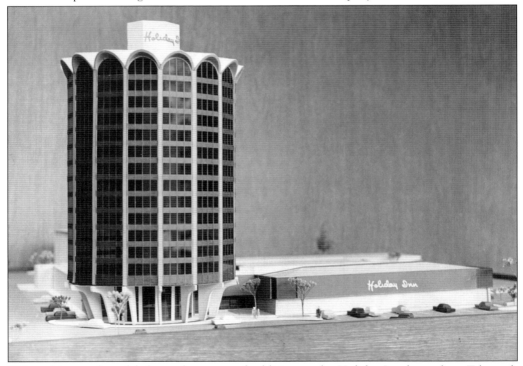

This architectural model shows the proposed addition to the Holiday Inn located on Telegraph Road. Upon completion in 1975, the cylindrical tower was topped with a restaurant called the Ronde-View. The outer ring of the restaurant rotated slowly around a stationary core and completed a full circuit in about one hour. When the tower was finished, it added 192 guest rooms, making it the largest Holiday Inn in Michigan.

North Park Plaza was built in 1973. Designed by King & Lewis as an office building, initially, this building was reportedly the first building in Michigan to use water-filled steel columns as both a money savings and a fireproofing effort. About 20,000 gallons of water plus a corrosion inhibitor and anti-freeze was used to fill the exterior steel columns. Perhaps in relation to this unusual construction method, in 2014, it was deemed unfit for renovation and demolished.

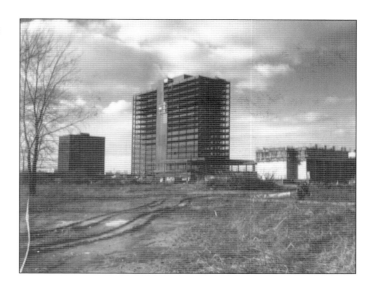

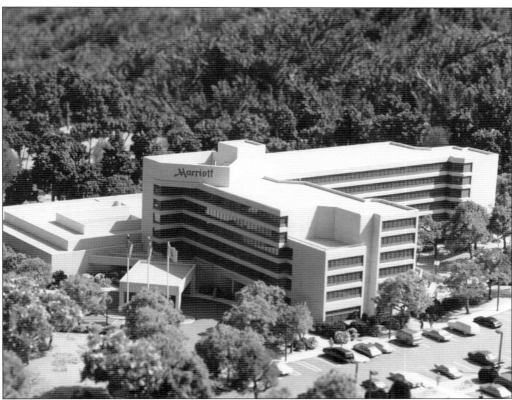

As Southfield's office space dramatically increased in the 1970s and 1980s, more hotels were built to keep pace with demand. An architectural model of the Marriott Hotel from 1987 is shown here. Located at 27033 Northwestern Highway, the Marriott Hotel opened in 1988–1989 and published advertisements in the late 1980s catering specifically to business travelers.

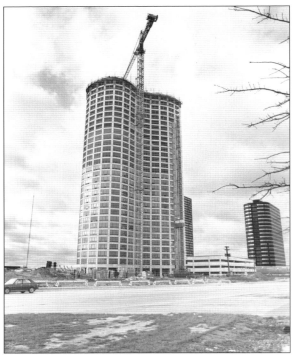

As originally planned, the Prudential Town Center was a 67-acre master-planned development with over 1.7 million square feet of commercial office space. As planned, it was a complex of four high-rise office towers, two high-rise condominium towers plus shopping centers and parking facilities. The buildings include 1000 Town Center, 2000 Town Center, 4000 and 4400 Town Center, and 5000 Town Center. The 5000 Town Center building, pictured at left, contains condominiums. Condo units ranged from one-bedroom to three-bedroom layouts and cost between $85,000 to $193,000 in 1982. The lush gardens of Prudential Town Center 3000 are shown in the 1977 photograph below.

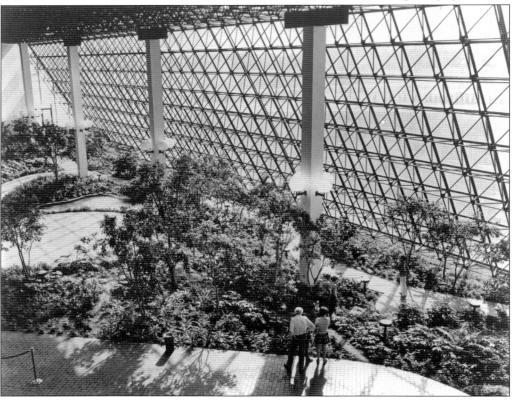

126

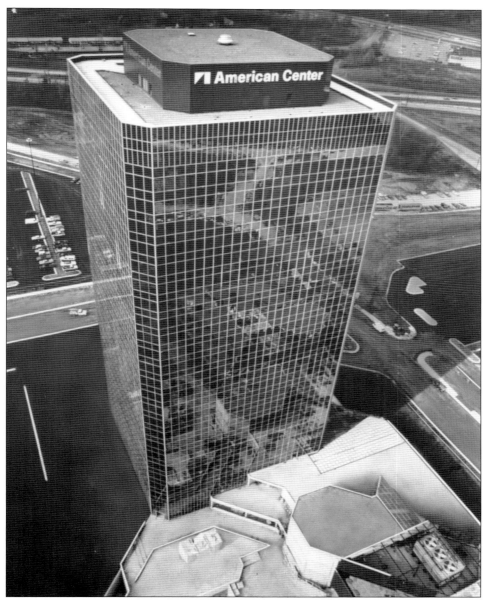

The American Center Office Tower was constructed in 1975 and was built by the American Motors Corporation (AMC) as its corporate headquarters. Designed by Smith, Hinchman & Grylls, this building won a Michigan Society of Architects Honor Award in 1976. In a bid to keep pace with Ford, General Motors, and Chrysler—the firms known as the Big Three—American Motors Corporation was formed by a merger of Nash-Kalvinator and Hudson Motor Car Company in 1954. By 1964, US automobile manufacturers had dwindled to the Big Three plus AMC, International Harvester, Kaiser Jeep, Avanti, and Checker. AMC's most popular cars included the Rambler, Ambassador, Hornet, and after purchasing the Kaiser Jeep division from Kaiser Industries, the Jeep. AMC occupied about one-third of the floor space in the building while the rest was leased to other tenants. Parking for 1,900 vehicles and retail, restaurant, and banking were housed in a four-story wing adjacent to the tower.

Discover Thousands of Local History Books Featuring Millions of Vintage Images

Arcadia Publishing, the leading local history publisher in the United States, is committed to making history accessible and meaningful through publishing books that celebrate and preserve the heritage of America's people and places.

Find more books like this at
www.arcadiapublishing.com

Search for your hometown history, your old stomping grounds, and even your favorite sports team.

Consistent with our mission to preserve history on a local level, this book was printed in South Carolina on American-made paper and manufactured entirely in the United States. Products carrying the accredited Forest Stewardship Council (FSC) label are printed on 100 percent FSC-certified paper.